HARROGATE
IN
50
BUILDINGS

MALCOLM NEESAM

AMBERLEY

Dedicated to my friend and fellow historian Anne Smith

First published 2018

Amberley Publishing, The Hill, Stroud
Gloucestershire GL5 4EP

www.amberley-books.com

ISBN 978 1 4456 8111 5 (print)
ISBN 978 1 4456 8112 2 (ebook)

Origination by Amberley Publishing.
Printed in Great Britain.

Contents

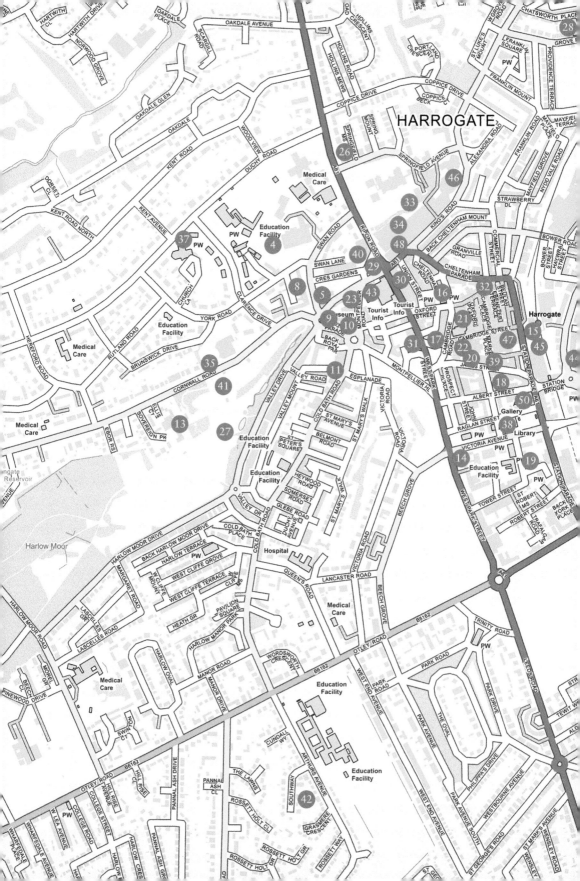

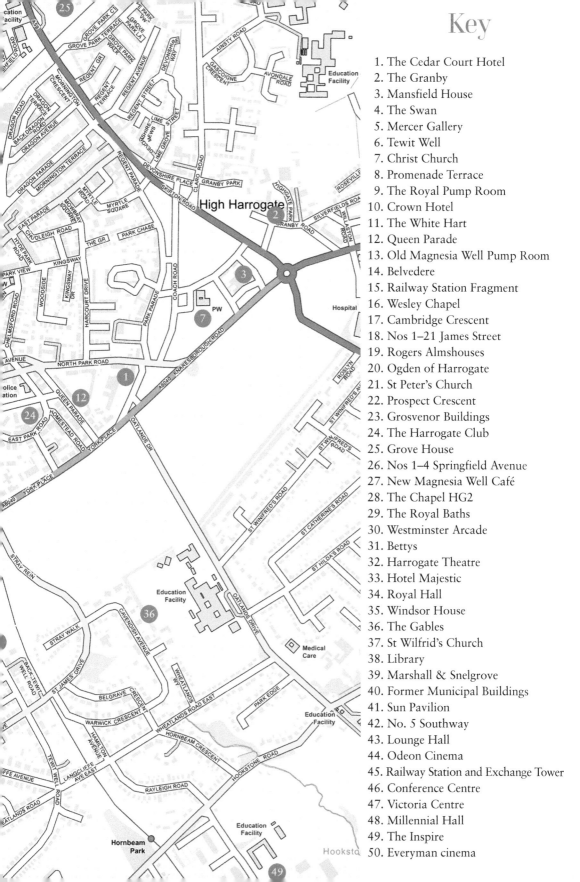

Key

1. The Cedar Court Hotel
2. The Granby
3. Mansfield House
4. The Swan
5. Mercer Gallery
6. Tewit Well
7. Christ Church
8. Promenade Terrace
9. The Royal Pump Room
10. Crown Hotel
11. The White Hart
12. Queen Parade
13. Old Magnesia Well Pump Room
14. Belvedere
15. Railway Station Fragment
16. Wesley Chapel
17. Cambridge Crescent
18. Nos 1–21 James Street
19. Rogers Almshouses
20. Ogden of Harrogate
21. St Peter's Church
22. Prospect Crescent
23. Grosvenor Buildings
24. The Harrogate Club
25. Grove House
26. Nos 1–4 Springfield Avenue
27. New Magnesia Well Café
28. The Chapel HG2
29. The Royal Baths
30. Westminster Arcade
31. Bettys
32. Harrogate Theatre
33. Hotel Majestic
34. Royal Hall
35. Windsor House
36. The Gables
37. St Wilfrid's Church
38. Library
39. Marshall & Snelgrove
40. Former Municipal Buildings
41. Sun Pavilion
42. No. 5 Southway
43. Lounge Hall
44. Odeon Cinema
45. Railway Station and Exchange Tower
46. Conference Centre
47. Victoria Centre
48. Millennial Hall
49. The Inspire
50. Everyman cinema

Introduction

Harrogate's unique appearance is the result of several unconnected factors that came together at key moments to determine the layout, design, purpose and growth of the community. Geology gave Harrogate the greatest variety of mineral waters of any place on earth. Geography set Harrogate amidst the glorious scenery of the Yorkshire Dales, with its pure air and water. Climate moulded the original inhabitants into a tough breed, whose survival required hard work and tenacity. Power placed the entirety of Harrogate within royal ownership, who prevented the rapacious exploitation of natural resources that ruined less happy communities. Fashion ensured that Harrogate (although a very old community that existed for centuries before the earliest documentary evidence from 1332) remained un-urbanised until the fashion of naturalistic spas arrived in the early nineteenth century, when the royal ownership ensured the subsequent explosive growth was brilliantly planned. Until the arrival of the railways in 1848, Harrogate was a town of stone buildings, the stone coming from several quarries awarded by the Crown in the Great Award of 1778 by which the old Royal Forest was broken up. After 1849, the railways imported brick, the first important brick building being the central railway station.

Harrogate's earliest history shows that before the coming of the railways and the development of the turnpike roads, only those visitors with the financial means to provide private transportation and the requisite security could brave the hazardous journey to remote Harrogate. This ensured that it was the upper classes who patronised the spa, and it was to cater to such guests that the town's amenities were created. When urbanisation took off in the early nineteenth century, the aristocratic preference was classical, so Harrogate's first public buildings reflected this. Later, the Italian Renaissance took over, this in turn being followed by the Arts and Crafts movement, art deco, and even brutalism, all of which reflected the tastes of the age in which they occurred, as well as the preferences of whichever class held sway.

It was greatly to the town's benefit that several far-sighted master builders were living and working in Harrogate at the time of its greatest urbanisation during the years between 1850 and 1914, and that their pride in the community ensured the best standards of architectural practice were followed. Thanks to them, new buildings were soundly constructed with local material, often beautiful in appearance and – most significantly – in a recognisable vernacular style with which people could identify. Oswald Spengler's dictum that ornament was evidence of

an artist's confidence to mould material to their will, had not yet been sacrificed to the cost-cutting mania for mass-produced prefabrication and right angles. Thanks to builders such as Richard Ellis, George Dawson and David Simpson, and architects such as John Clarke, Arthur Hiscoe, J. H. Hirst, the Bown family, and the Whitehead and Smetham partnership, Harrogate's architecture flourished. It is their work that residents and visitors cherish, and which to this day attracts the tourists.

The fifty buildings described in this book have all been affected in some way by their settings, the most influential being elevation (for Harrogate's geology has created a town of hills and valleys) and a sense of spaciousness. This last can be seen with the 200-acre Stray, presented to the town by the Crown in 1778, both to safeguard all the then known mineral wells, and also to provide space for health-giving exercise. This spaciousness also influenced Harrogate's broad, tree-lined avenues, and the number of gardens and squares, of which Valley Gardens became the best known. The two factors of elevation and spaciousness often determined the purpose and appearance of buildings described in this book.

Regularly named the happiest place to live in England, Harrogate continues to recognise the importance of visitors and delights in sharing its uniqueness with all who wish to enjoy its charms. The town's current motto, 'To Be of Service', is just as applicable today to tourists or exhibition and conference delegates as it was when nobility and aristocracy crowded into Harrogate to drink its unrivalled mineral waters at a time when the motto was '*Arx Celebris Fontibus*' – 'a citadel famous for its Springs'.

Please note that dates refer to the age of buildings, rather than businesses or occupants.

The 50 Buildings

1. The Cedar Court Hotel, 1671

Harrogate's oldest purpose-built hotel, originally known as the 'Queen's Head', opened in either 1671 or 1687 depending on which historian is consulted, the former date being the most logical of the two. The queen in question would have been Charles II's consort, Catherine of Braganza, who in 1665 was granted the revenues of the Royal Forest, of which Harrogate was part. Harrogate had become a popular resort for visitors following William Slingby's 1571 discovery of the mineral waters of the Tewit Well, and before the Queen's Head opened, such visitors had usually been accommodated in surrounding villages or local farmhouses.

By the middle of the nineteenth century the Queen Hotel, as it had become, had greatly increased in size, its location halfway between the Tewit and St John's Wells, and on the highway between Harrogate and Knaresborough, proving an ideal location for visitors in search of health. The attached Queen Farm, which raised foodstuffs for the hotel, had 70 acres of land, but the arrival of the railways

The Queen Hotel before the 1856 rebuilding.

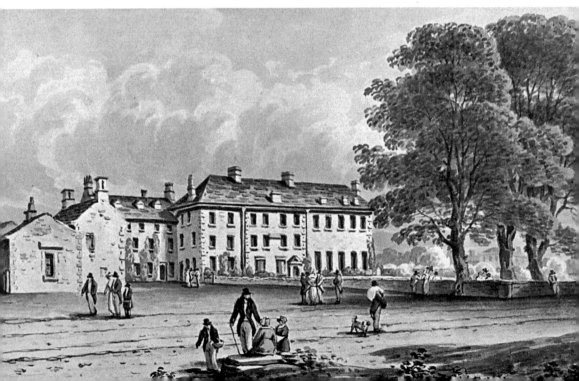

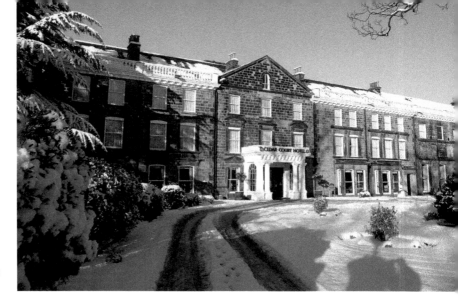

Today's
Cedar Court
Hotel.

in 1848 meant that food could be supplied by rail, and consequently much of Queen Farm was sold for housing, an excellent example of which may be seen on Queen Parade, due west of the hotel.

The sale of Queen Farm enabled the owner to refront the hotel's main façade, the wing to the east, or right, being the oldest part of the building, and the central gable with its pillared entrance portico, and the left, or western frontage dating from the 1855–56 rebuilding. Always one of High Harrogate's top three hotels, the Queen survived the closure of its two old rivals, the Dragon and the Granby, and during the Second World War it served as home to the Air Ministry's No. 7 Personnel Reception Centre. After later being home to the Leeds Regional Hospital Board, the building was partly dismantled and rebuilt in 1998 before being reopened as the Cedar Court Hotel in 1999. Today, its long and graceful stone façade contributes much to the beauty of the surrounding townscape.

2. The Granby, c. 1690

The Granby was for centuries Harrogate's most exclusive address, a place so exalted that only the nobility graced its interior, with lesser mortals being accommodated at the still surviving Queen or the long-demolished Dragon hotels. Nicknamed the 'House of Lords', the Granby probably owes its origins to a farmhouse that accommodated visitors to the nearby Tewit and St John's wells, whose mineral waters furnished long lists of successful cures. The oldest known name for the Granby Hotel was 'The Sinking Ship', a name that passed into common use with the scuttling of the Spanish Armada in 1588. Then came the 'Royal Oak', which had become popular after Charles II hid in the oak tree at Boscobel after the Battle of Worcester in 1651. It was during its period as the Royal Oak that the famous Blind Jack Metcalf, the Yorkshire Road Maker', eloped with the daughter of the landlord, Benson.

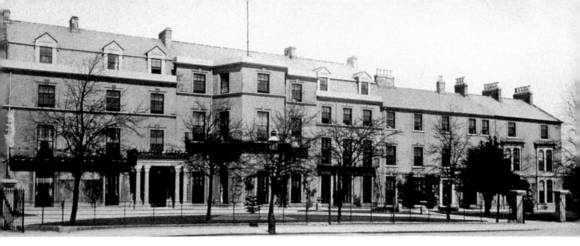

The Granby in the nineteenth century.

There is the strong possibility that the Granby name was adopted in 1764 because the landlord had been one of the Marquis of Granby's soldiers, who on retiring was given help by his humane commanding officer. This is why the Marquis of Granby was said to have more pubs and inns named after him than any other man in history. At one time, the most northerly part of the building, to the far left of the entrance, was a separate house where the owner lived, but by 1900, it has been incorporated into the main body of the hotel. Built over several centuries, the Granby's stuccoed façade covers a variety of building materials, making its frontage look more like a whole street than a single building. After the final closure of the hotel in 1992, the Granby became a high-quality residential care home, and in 2017–18 it was thoroughly refurbished for Granby Care Ltd.

The Granby today.

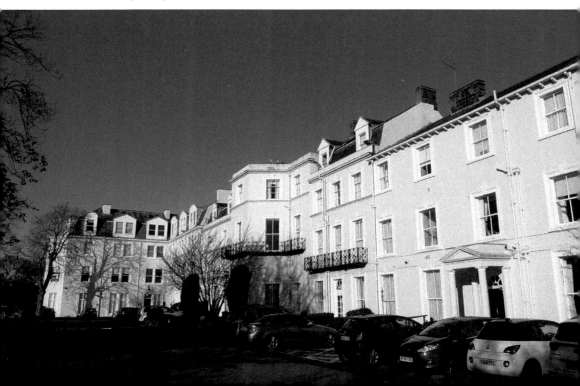

3. Mansfield House, 1788

Mansfield House was built in Church Square in 1788 as Harrogate's second purpose-built theatre. The first theatre had been erected in *c.* 1765 at No. 3 Devonshire Place, but closed in around 1776, probably because the large, three-storey building was too big. Theatrical productions then moved into Granby barn until the Granby's owner, Thomas Wilks, saw the potential for a new theatre and built what later became known as the Theatre Royal. The building is typical for the Georgian period, having a central bay with a high gable, pierced by an oculus window, and two flanking wings. The doorcase has an elegant pair of attached columns of the Tuscan order. Constructed of a lovely golden sandstone, the principal façade had at one time a thick coating of stucco, which may have been applied after 1830, when the theatre closed and the building was converted into residential use.

The theatre had been built to accommodate Samuel Butler's company, which played a circuit that included Beverley, Kendal, Northallerton and Redcar, the Harrogate visit being left to the height of the visitor season in July and August. Performances were given on Tuesdays, Thursdays and Saturdays, the programmes usually being assembled by canvassing the guests at the Granby and other great hotels. The Butler company often employed celebrated actors from London, such as Mrs Jordan, Tryphosa Jane Wallis, Edmund Kean and William Macready. The theatre seems to have accommodated around eighty people, the greater majority of whom would have been visitors, as few locals could have afforded ticket prices

Mansfield House.

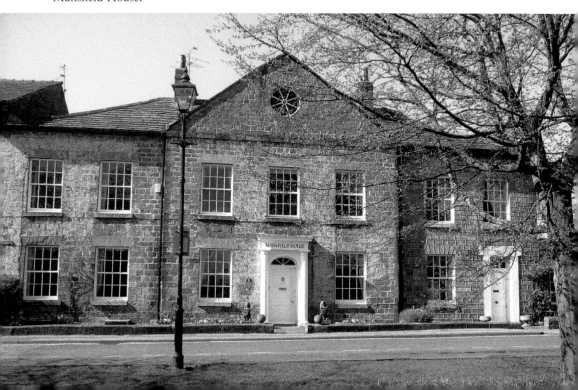

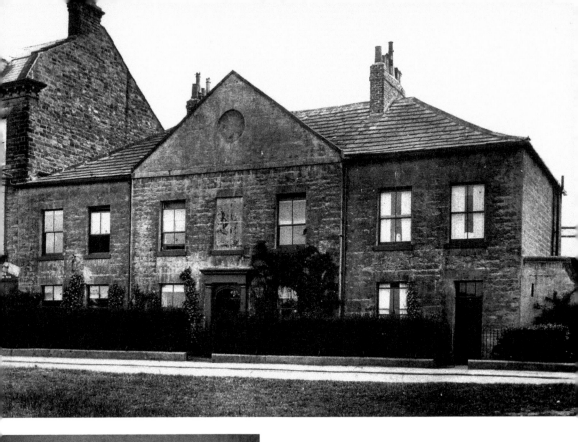

Above: Mansfield House in the nineteenth century.

Left: An eighteenth-century playbill.

that by 1819 reached five shillings for lower boxes, four shillings for upper boxes, three shillings for the pit and six pence for the gallery. Today, the beautifully maintained building is a private residence.

4. The Swan, *c.* Eighteenth Century

Today's Old Swan Hotel presents a most attractive appearance, its great stone frontage set behind lawns and trees, with a first-rate view of the Royal Pump Room and the very heart of Low Harrogate. Yet the Swan had humble beginnings, its first known name being the Smiths Arms, or, sometimes, the Blacksmiths Arms, a name probably derived from the number of smithies in the area connected to the iron ore trade between Haverah Park (which supplied timber) and the forges of Kirby Overblow. Once, the Swan overlooked Cornwall Road, the earlier name for this route being Irongate Bridge Road. But when the establishment was acquired by Thomas Shutt in 1782, who advertised that he had 'fitted it up in the neatest manner for the Spaw Season', the name was changed to the more aristocratic 'White Swan'.

By 1878 the Swan Inn had the most important transformation of its existence when it became the Harrogate Hydro. The new establishment rapidly became one of the town's top hotels, and catered to those Victorian clientele who took the rigours of the spa 'cure', with its emphasis on plain living, exercise and fresh air, and lots of mineral water, very seriously. The following year, the authority approved elaborate plans for a large new west wing, which was only a year after a disastrous

The Old Swan Hotel.

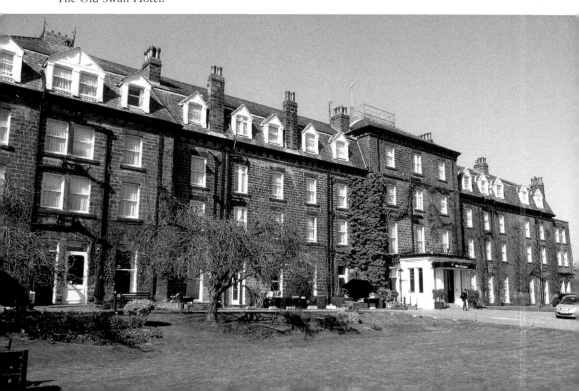

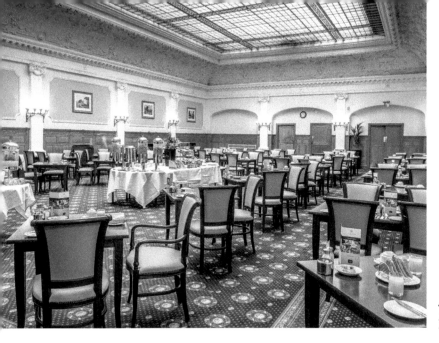

The Wedgwood Restaurant.

fire destroyed the newly built Turkish Baths, which were reopened speedily in time for the Christmas of 1878. It is interesting to recall that Karl Marx visited the Swan Hotel in 1873. Other famous guests include Agatha Christie in 1926 and Benjamin Britten in 1963. The Swan's magnificent public rooms made it a popular venue for Harrogate International Festival after its establishment in 1966.

5. Mercer Gallery, 1805

The handsome Italian Renaissance stone frontage of the Mercer Art Gallery was built in 1874–76 during renovation of the original Assembly Room that had opened in 1805. The Promenade Room, as it was originally named, had been paid for by a group of doctors who realised that if their patients extended their visits to Harrogate to enjoy the entertainments provided, the medical profession would surely benefit. The 1874 refurbishment was designed by architect Arthur Hiscoe, who gave the building an impressive internal hall with an elaborate coffered ceiling. Two new rooms were added, one on each side of the entrance, which was flanked by attached columns and a handsome entablature enriched with symbols of the locality. The new roof was embellished by a pair of French-style high pavilions typical of Hiscoe's other Harrogate work. Such artistes as Lilly Langtree and Oscar Wilde appeared here.

During the last decade of the nineteenth century, the Promenade Room served as a theatre but when the new Grand Opera House opened in 1900, the Promenade Room was used by the council for a variety of uses, including the Mechano-Therapeutic Department of the spa, and later, home to the Borough Treasurer's Office. But in 1991, after a successful appeal for funds, the Mercer Art Gallery opened in the magnificently restored building. The Mercer family's generous

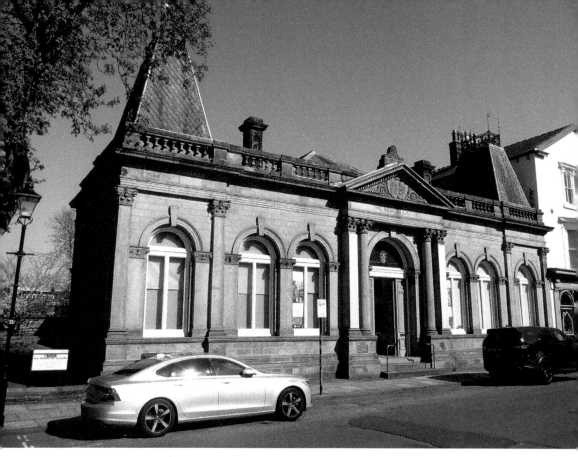

Above: The Mercer Art Gallery.

Below: The Mercer Gallery's interior.

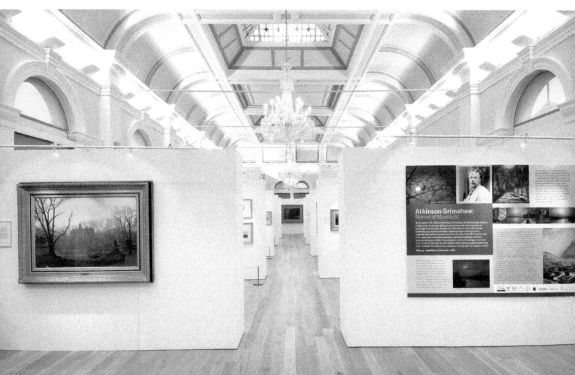

financial support was largely responsible for the success of the appeal. Since the nineteenth century, Harrogate Corporation had acquired an impressive collection of paintings and sculptures, fine examples of which are frequently exhibited. But the Mercer Gallery also has a splendid record of showing contemporary art and of encouraging children to take an interest in the arts. Today, entering the Mercer Gallery should be an unmissable part of every visitor's experience of Harrogate.

6. Tewit Well, 1808

This pretty little temple, located on the south Stray, was highly influential with the introduction and development of the classical style of architecture in Harrogate. In June 1807, only two years after the opening of the Promenade Room, a group of townspeople met at the Hope Inn to consider improvements to the famous Old Sulphur Well, which by the beginning of the nineteenth century was protected by a rudimentary stone cover, open on one side, from which the 'Well Women' could draw water for visitors. As the well was on Stray land, any new building had to be open, so when Thomas Chippindale was asked for a design, he produced an

The Tewit Well, discovered in 1571.

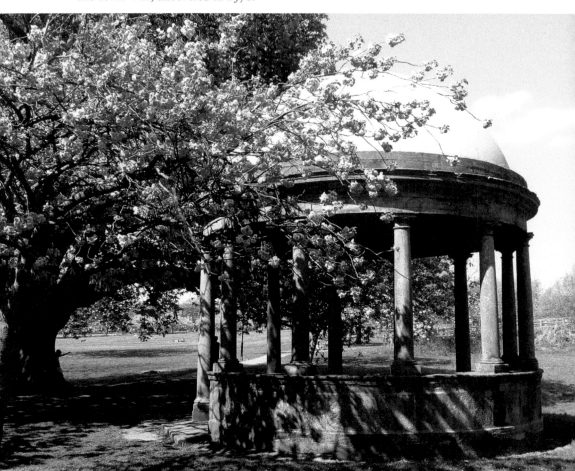

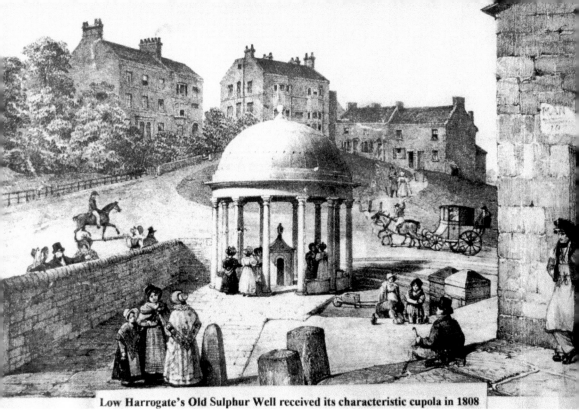

Low Harrogate's Old Sulphur Well received its characteristic cupola in 1808

The Old Sulphur Well Temple in *c.* 1820.

elegantly simple domed 'temple' supported by twelve Tuscan columns, some of which had a low wall to retain the soil of the bankside. Built at a cost of £263.6s, the new 'Pump Room', being completely open, enabled malicious persons to vandalise the well at night, and so in 1842, after an Act of Parliament had been passed, a new and completely enclosed Pump Room was opened, the Chippindale temple being dismantled and moved to the Tewit Well, which had been discovered by William Slingsby in 1571.

The Tewit Well, an iron or chalybeate water well, was the first mineral well in England to be called a 'spa', after Dr Timothy Bright's description of 1598, making it of considerable historical significance, apart from the many cures it provided. It is therefore all the more incredible to record that in 1971, after exactly 400 years of public use, Harrogate Borough Council turned off the pump and disconnected the supply, which had been granted to the public since an Act of 1770.

7. Christ Church, 1831

Harrogate's first place of worship to be built since the loss of its medieval chantry chapel in 1550 was the Chapel of St John, which was opened in 1749 on a site adjacent to the present building of Christ Church. The chapel was built largely for the convenience of visitors to the spa, rather than for local people, and indeed

was funded from subscriptions headed by Lady Elizabeth Hastings, the land being conveyed by the king through the good will of the Duchy of Lancaster. The growth of the spa during the later eighteenth and early nineteenth century meant that by 1812 St John's was too small for the expanded congregation, and consequently extension works were undertaken, which gave St John's a decade or so of further use. By 1830, however, it was clear that the dilapidated state of St John's meant a replacement structure could no longer be postponed, and on 1 October 1831 the Bishop of Chester consecrated the new church, which had been designed by John Oates of Halifax in an elegant Early English style. The famous Bradford architects Lockwood and Mawson added the chancel and transepts in 1861–62.

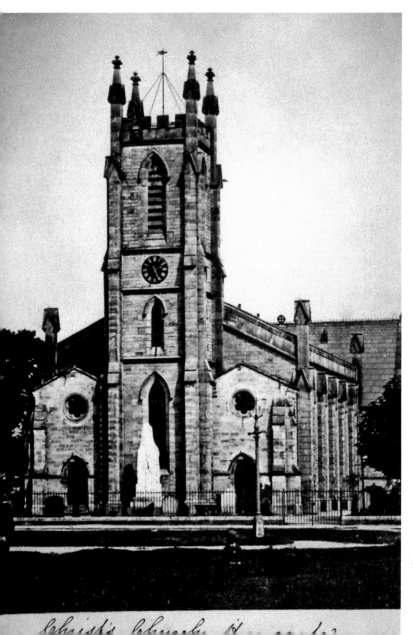

Christ Church after the 1831 rebuilding.

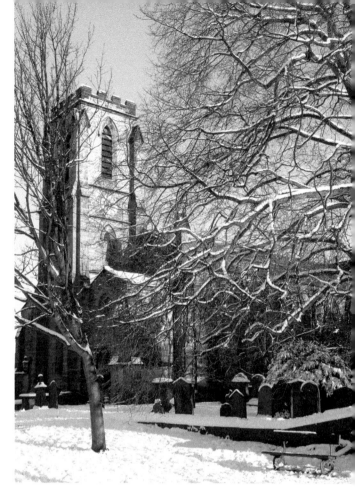

Right: Christ Church today.

Below: Christ Church's fine interior.

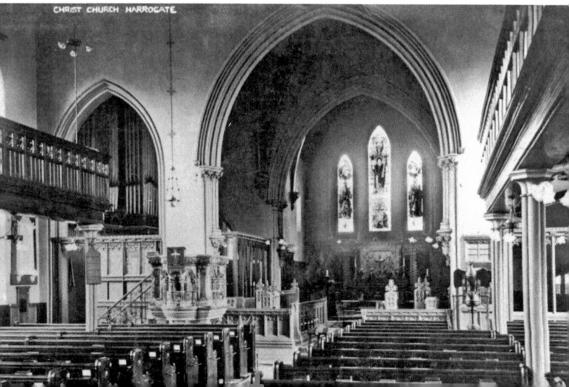

Its Stray position perhaps gives Christ Church the most picturesque location in Harrogate, where the greenness of the grass and trees form a fine foil to the austerely crisp outline of the stone building's architecture. The superb tower lost its four corner finials in 1938, which if anything improved the austere simplicity of the building's outline. The church contains a gallery and a fascinating range of memorials to visitors who came to Harrogate in search of health, but instead found eternal repose. The crypt beneath the church, which is only occasionally open for inspection, contains the vaults of the Frith and the Sheepshanks families. The much-used Parish Hall designed by Peter Hill was opened in 1988.

8. Promenade Terrace, 1839–42

Promenade Terrace was the Duchy of Lancaster's first planned development of the land that later became known as the Duchy Estate, although subsequent designs changed the building form from terrace to detached and semi-detached villas surrounded by large gardens. The terrace was conceived by John Howgate, who was appointed by the duchy's attorney general, and it was Howgate who

One of the superb houses at Swan Road's Promenade Terrace.

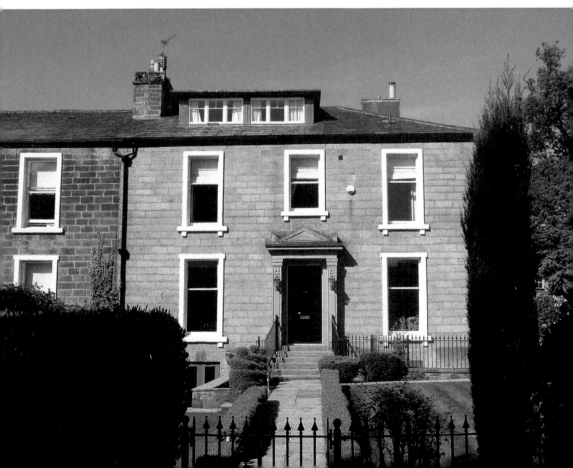

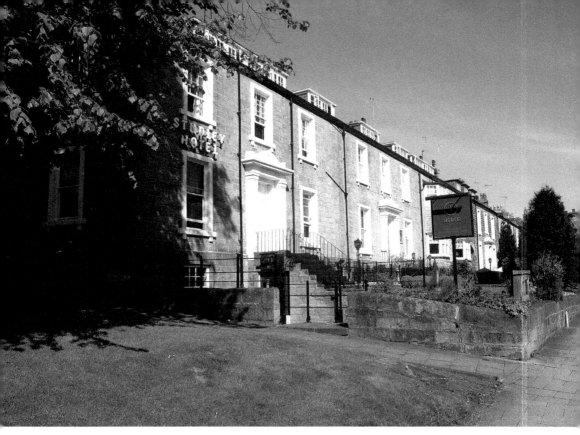

Promenade Terrace, Swan Road.

appointed Isaac Thomas Shutt, son of the owner of the neighbouring Swan Inn, as architect. Shutt's design was a rather late exercise of the aristocratic Georgian classicism that was such a feature of the previous two decades, a superb example of which may be seen in the accompanying image. The twentieth century saw some disfigurements to the terrace by the addition of a few commonplace bay windows, but despite this, the terrace provides the Low Harrogate valley around the Old Sulphur Well with a handsome architectural backdrop. Perhaps the most impressive feature of the terrace, apart from the finely proportioned façade, is that it was built on a raised platform in order to protect the locality's mineral springs. Most of the terrace, which was originally intended as part of a larger development, was built in stages from 1839 to 1842 by speculating builder Thomas Humble Walker, who leased plots from the duchy before building them to Shutt's design.

9. The Royal Pump Room, 1842 and 1913

Perhaps more than any other building, the Royal Pump Room has become the symbol of Harrogate. It owes its origin to an 1835 attempt to divert the water of the Old Sulphur Well from the public open land of the Stray to the private enclosed land of a neighbouring landlord. The resulting shock to the town resulted

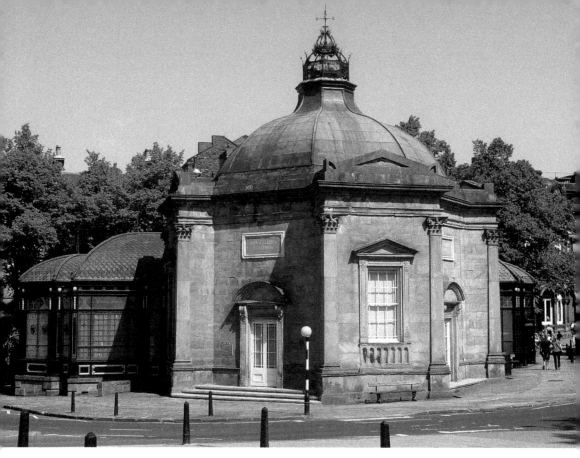

The Royal Pump Room now contains Harrogate Museum.

in a new Act of Parliament to better protect the wells and improve the town's administration by the establishment of the Improvement Commissioners, whose first act was to build the Royal Pump Room. Architect Isaac Thomas Shutt used the traditional language of classical architecture to highly unusual effect, applying it to a domed octagonal building whose only precedent appears to have been Berlin's German Cathedral of 1701–08. The window frames are in a particularly pleasing classical form, although erosion has reduced their crispness. The splendid dome, originally lead but replaced with copper in 1950, was once crowned with a florid lantern held aloft by five wooden dolphins, but when they perished in the late nineteenth century, they were replaced by the present decorative iron structure. By 1900, crowding at the Royal Pump Room was so problematic that the council were debating whether or not to extend the building with an annex, or to replace the 1842 building with a large new structure of Edwardian baroque design. Fortunately, the former option was adopted, and in 1913, the Lord Mayor of London opened the handsome iron and glass annex, which was embellished with decorative copper roof tiles. The 1842 building was paid for by an admittance charge of two pence, but to preserve the rights given to the public by the Act of 1770 to drink the waters without charge, an outside free tap has always been provided. Today, the Royal Pump Room contains Harrogate's Museum.

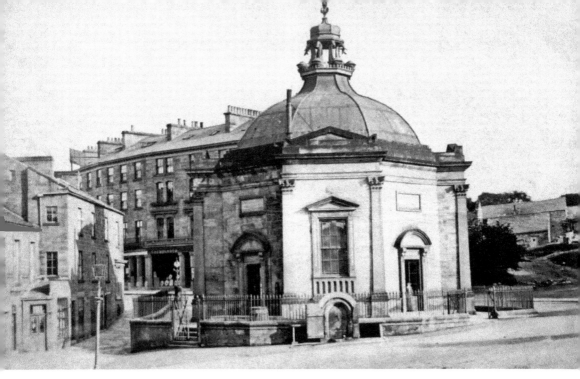

Above: The Royal Pump Room with its original lantern.

Below: The Royal Pump Room's annex of 1913.

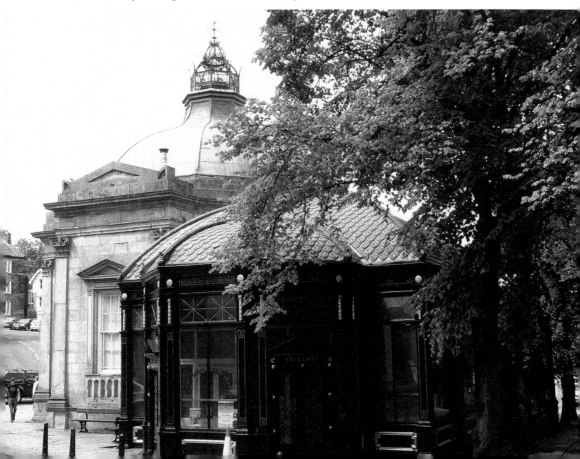

10. Crown Hotel, Seventeenth and Nineteenth Centuries

This glorious Victorian exercise of Italian Renaissance in sandstone has a long and distinguished history that reaches back to the early 1600s when visitors first began to drink the waters of the world's strongest known Sulphur Well. The name 'Crown' may have been adopted around the time of Charles II's restoration of the monarchy in 1660, when a much smaller inn overlooked the Sulphur Well to the west. Since then, the Crown thrived, reaching 'gigantic proportions' by the time Lord Byron and his 'string of horses, dogs and mistresses' were guests in 1806. The Crown is also the most likely place were famed authoress Maria Edgeworth stayed in 1826, when she enjoyed the company of the great scientist Sir Humphrey Davy. At this time, the Crown presented a long row of disparate buildings of Georgian appearance, the main dining room being more or less where the present one is placed. The Crown was more like a miniature village than a hotel, as it had its own farm where food was produced, workshops, a smithy, a laundry, extensive stables and a team of blacksmiths, carpenters, masons and bakers. In 1828, the *York Herald* reported, 'Fancy Ball at Harrogate ... the spacious ballroom, at the Crown Hotel, was thrown open to upwards of 200 fashionables, amongst whom were not a few whose rank, beauty, taste, and correctness of costume had attracted notice in the brilliant festival of the preceding week. It were difficult to select objects for particular remark, where so much was to be admired.'

In 1847, the central section of the Crown was rebuilt in a chaste neoclassical design, almost certainly the work of architect Isaac Thomas Shutt. Then, in 1870,

The eighteenth-century Crown Hotel frontage.

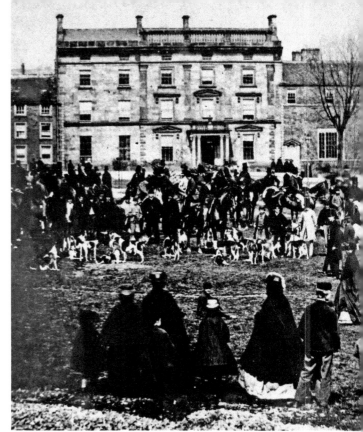

Right: The Crown after its
1847 rebuilding.

Below: Today's Crown Hotel.

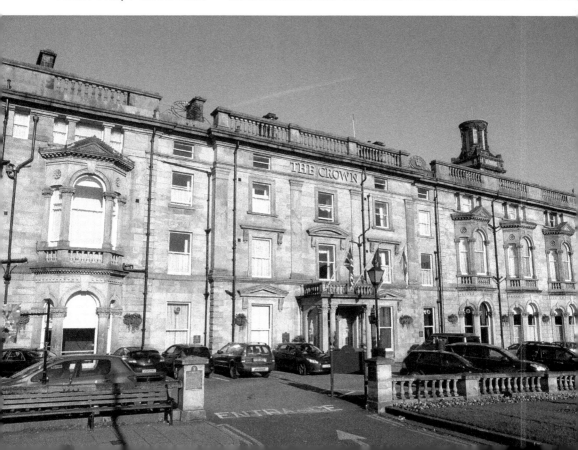

the Crown estate – which then ran up as far as Parliament Street – was acquired by George Dawson, who employed J. H. Hirst of Bristol as his architect. The Crown's Georgian wings were removed and replaced by Hirst with a powerful pair of Italian Renaissance replacements that gave the building great character and nobility. Dawson also planned a tower and new shops in Crown Place and Crescent Road, all of which were built after Dawson's death in 1889. When Elgar stayed at the Crown in 1912, it was probably at the peak of its Edwardian perfection. After being sequestered by the government in 1939, the Crown reopened to visitors in 1958.

11. The White Hart, 1847

Sir Nikolaus Pevsner called the White Hart, a former Coaching Inn, Harrogate's finest building, but then Sir Nicholas Pevsner had not known the Spa Rooms. Still, the White Hart is superb, being a crisply elegant exercise in neoclassical design, to which an exuberant spirit of innovation has added some unexpected and attractive features. As a hostelry, the White Hart is far older than the present building, which was put up in 1847, the same year as the central portion of the Crown Hotel was built, just across the Stray to the north-east. The most striking feature of the White Hart's principal façade is the range of arched windows that runs so rhythmically along the ground-floor façade, an effect that is enhanced by placing the main entrance not at the expected centre, but offside to the right, where it is flanked

The White Hart was rebuilt in 1847.

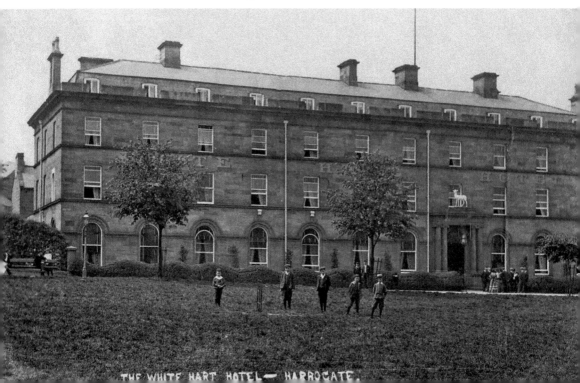

THE WHITE HART HOTEL — HARROGATE.

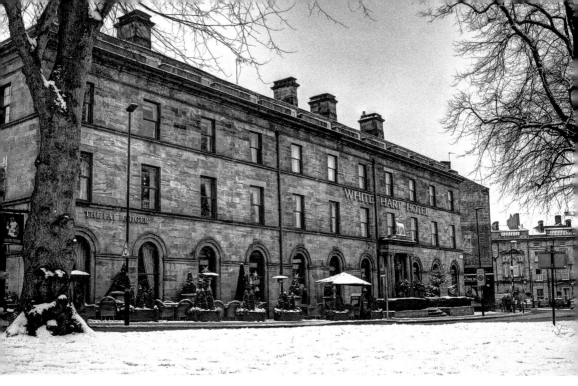

The beautifully located White Hart overlooks the Stray.

by pairs of columns in the Ionic order that support the entablature, the whole composition crowned by an imposing White Hart.

The White Hart's mansard roof is notable, as the highly unusual alternation of dormer windows and balustrade crenellation sets up a rhythm, which complements that created by the ranges of the lower storeys, this feature being unique in our experience. Another notable aspect of the White Hart's frontage is the superb quality of the ashlar finish, which shows every sign of high craftsmanship. Designed by architect G. T. Andrews, the builder Atack went on to build Leeds' town hall. Atack seems to have rushed his Harrogate commission, as the White Hart soon developed a bulge that had to be dressed up. After centuries as a hotel, the White Hart was taken by the government in 1939 to accommodate some of the ministries evacuated from London, and the Air Ministry moved in. The war over the White Hart was bought by the Leeds Regional Health Authority in 1949 and used for a variety of purposes until it again became a hotel.

12. Queen Parade, 1850s

Queen Parade and its villas, which date mostly from the middle of the nineteenth century, are representative of the changes and opportunities brought to Harrogate by the arrival of the railway in 1848. Before this time, much of the great expanse of land west of the old Queen Hotel was used by the hotel as farmland to produce food for the hotel's kitchens. But the coming of the

railways, following in the trail of the 1841 Harrogate Improvement Act, meant that provisions could be imported by rail, freeing the increasingly valuable land between Park Parade, York Place and West Park for urbanisation. The development of Queen Parade appears to have begun in 1855, the same year that Queen Hotel owner Dearlove sold it to new owner Henry Milner, who immediately planned major improvements to the old hotel. These were financed through the development of redundant Queen Hotel farmland, and in May 1857 Milner surrendered two dwelling houses 'now in the course of erection' to Edmund G. Hallewell for £600. These were Nos 2 and 4 Queen Parade, and in their solid construction and pleasing architecture they set a high standard for future building. Much of Queen Parade, which until the late nineteenth century was a cul-de-sac, was built by either Richard Ellis or the Simpsons, who employed several architects. The parade's most impressive villa is Oak Lea, originally No. 10 but today No. 12, which has much superbly finished masonry and great arched bay windows. This was built by Richard Ellis to a design by Perkin, who designed the other Ellis houses on Queen Parade's west side. Among Queen Parade's other handsome villas must be counted Nos 11 and 13, with their substantial decorative iron canopies.

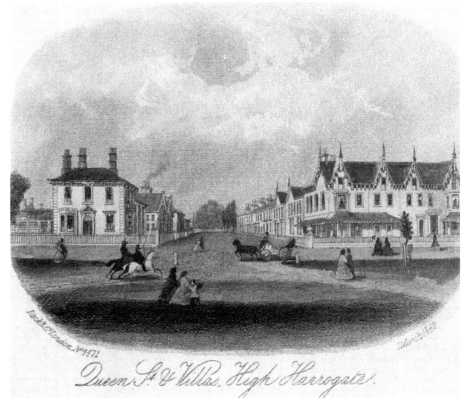

This 1862 print shows Queen Parade as a cul-de-sac.

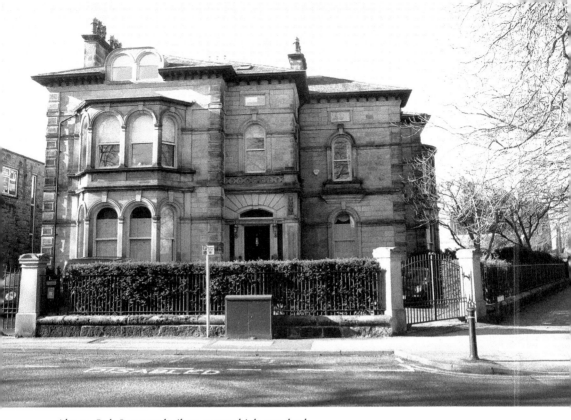

Above: Oak Lea was built to a very high standard.

Below: Two villas embellished with elaborate iron canopies.

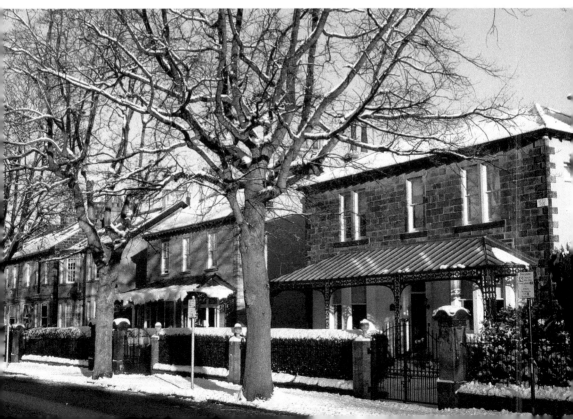

13. Old Magnesia Well Pump Room, 1858

The Magnesia Well in today's Valley Gardens really lies on a portion of Harrogate Stray that is known as 'Bogs Field', so named because in earlier times the up-welling mineral springs turned the land into a bog. Always the most popular of Harrogate's Mineral Wells with the townspeople, the date of the original discovery of the Magnesia Water's medicinal properties is unknown, although it may have been among the Bogs Field waters praised by Dr Short in his 1734 *History of the Mineral Waters*. Used to treat cases where the kidneys required stimulation, the Magnesia Water was classed under the mild sulphur group, and was thus easier to consume than its near relations, the Bogs Field No. 36 Well and the Mild Montpellier Sulphur water of the Royal Baths estate. The popularity of the Magnesia Water led the Improvement Commissioners to build a pump room where visitors could drink the water in relative comfort, and in 1858 the Magnesia Well Pump Room was opened, a few yards from the Magnesia Well, whose waters were piped into the Pump Room. Architect John Stead produced a design in the Gothic style, with a steeply pitched roof clad in fishtail slate, deeply protruding bargeboards, leaded lancet windows and a series of pointed wooden finials that enliven the delightful little building. An outside tap at the building's rear once enabled drinkers to do so without charge, free access to the mineral wells having been guaranteed by the Act of Parliament of 1770. The charge to enter the pump room was for the use of the building, whose attendant would serve visitors.

The Magnesia Well Pump Room opened in 1858.

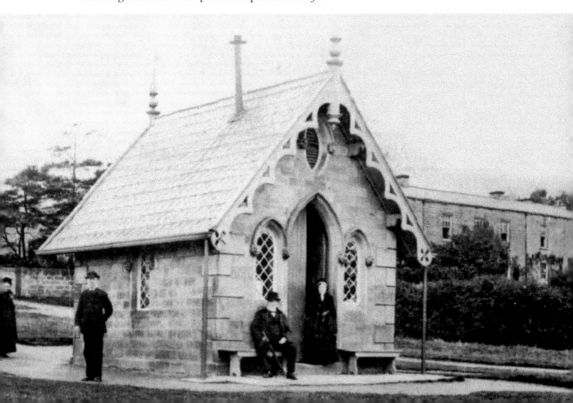

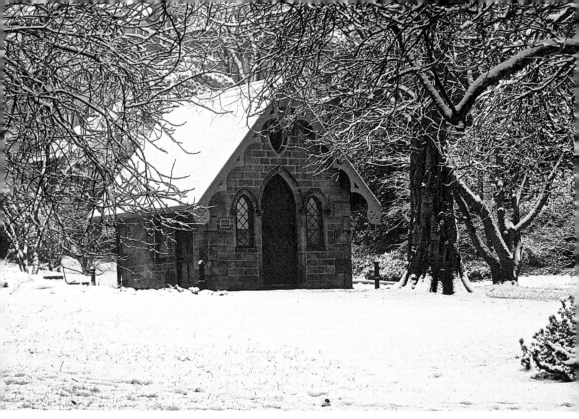

The restored Old Magnesia Well Pump Room.

Such was the growing popularity of the Magnesia Well Pump Room that in 1895 the council built the New Magnesia Well Pump Room, today the Valley Gardens Cafe, the older pump room of 1858 then being largely used as a storeroom, and for a few years before the First World War, as a museum. Thanks to the Friends of Valley Gardens, the Old Magnesia Well Pump Room was beautifully restored in 2015.

14. Belvedere, 1862

When the Victoria Park Company was founded in 1860 to urbanise the agricultural land separating the two medieval villages of High and Low Harrogate and thus create a single town, its show street was intended to be Victoria Avenue. At the point where Victoria Avenue joined West Park and the Stray, two imposing structures were conceived; one of them, the Congregational Church, now the United Reformed Church, was erected in 1861–62, and the site opposite received a splendidly florid mansion for banker John Smith, a partner of Messrs Beckett and Co. The Belvedere is in the style of Victorian architecture that can be referred to as 'Tudorbethan' – i.e. a Victorian ideal of what Tudor architecture should be. With its porte cochère, ogee dome, bartisans and crenellations all executed in superb masonry, the Belvedere is a joyous exercise of confident Victorianism that should delight the eyes of the viewer. The architects, Perkin and Backhouse, were

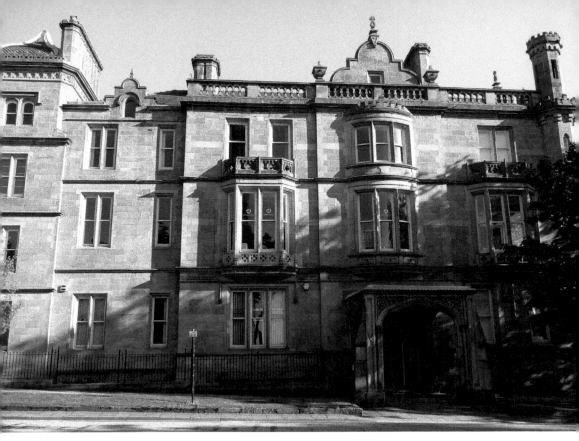

Today's Belvedere.

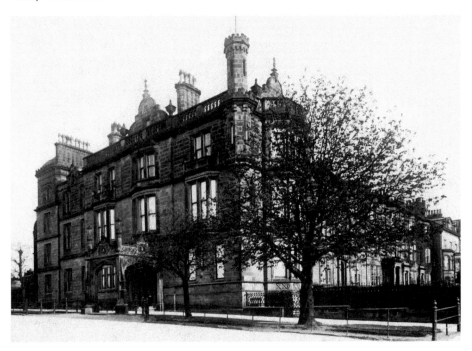

The Belvedere of 1861–62 provides Victoria Avenue with a flamboyant introduction.

clearly enjoying themselves when they built Belvedere, and although the lavish garden to the east, with its once impressive conservatories, has long gone, enough of the original house remains to still provide Victoria Avenue and West Park with a visually arresting experience.

After John Smith's death in 1866, Belvedere was occupied by George E. Donisthorpe, whose patents for wool-combing machinery brought him into contact with Samuel Cunliffe Lister, of Manningham Mill fame, whose business partner he became. After Donisthorpe's death in 1907, Belvedere was bought by Lord Faber, who in 1900 was host to the great novelist Sir Henry Rider Haggard, visiting Yorkshire to research his study of rural England. Acquired by the YMCA in 1920, Belvedere became a memorial to victims of the First World War, with the names of the fallen inscribed on panels in a room of remembrance. Today, the Belvedere accommodates business premises.

15. Railway Station Fragment, 1862

At the beginning of 1860, visitors arriving at Harrogate by railway had to disembark at either the Brunswick station at the junction of Otley and Leeds roads, or at Starbeck. This was not convenient for the visitors, nor of use to the increasing numbers of retailers who sprang up in central Harrogate as a result of the Victoria Park Company's activities. The Improvement Commissioners were aware of public dissatisfaction with the railway system, and on 3 September 1860 they agreed to send a memorial to the railway company, asking them to complete the branch line to central Harrogate in time for the season of 1861. Thus prompted, the railway company began construction work for the new central railway line in 1861, and on 27 July 1861 tenders were advertised for the construction of a new railway station in central Harrogate, the applications to be

This early photo shows the original railway station.

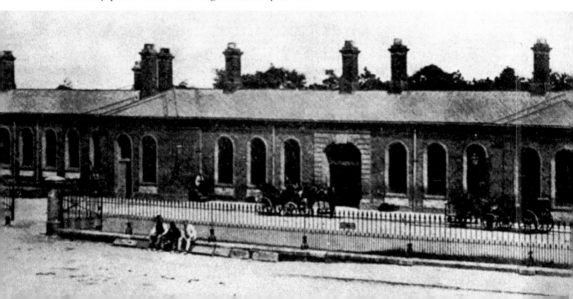

sent to Mr Prosser, the company's architect. Partly isolated in green fields, the new station was designed for North Eastern Railways by Thomas Prosser with two facing platforms without either bridge or subway link – an unsatisfactory state of affairs not rectified until 1873 when a footbridge was added. It was the first major structure in Harrogate built of brick, using a pleasing mixture of the warm red brick seen on many other North Eastern Railway stations and Pease's white glazed brick (also known as Scarborough brick). The windows of the long, single-storey structure had architraves of sandstone, with attractive arched tops. Each end was terminated by a slightly taller square water tower, and the new railway station was opened for use on 1 August 1862.

It was because Harrogate had been built of stone that Prosser's use of brick was so significant, and in the following decades several further brick buildings were erected, such as the Exchange in Parliament Street and residential properties at the Oval and East Park Road. Perhaps the most significant later brick buildings were those erected around 1900, when the Grand Opera House and Hotel Majestic opened.

In 1965, Harrogate's Victorian railway station was very largely demolished in what many citizens regard as having been an act of unutterable folly, the only part of Prosser's original station to survive being the north wing containing various offices and the refreshment room. After removing several unsightly later additions, this section was restored to accommodate a beautiful pub, the Harrogate Tap, which has successfully re-created the atmosphere of the town's lost railway station.

Harrogate railway station at its peak.

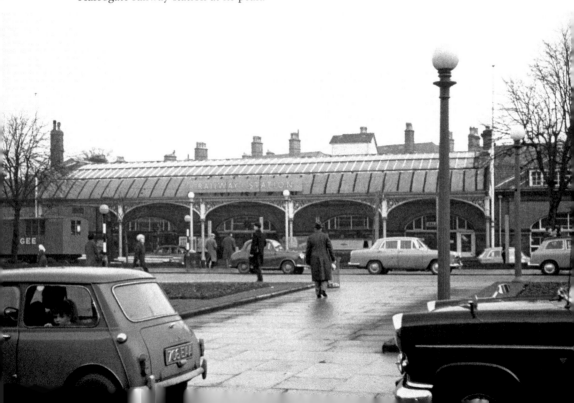

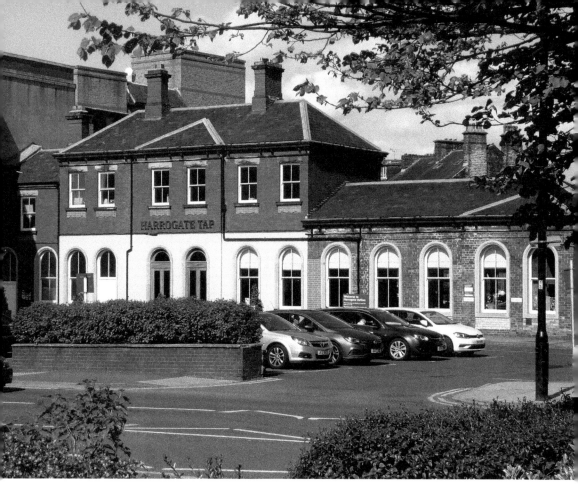

Today, only this fragment remains from the original railway station.

16. Wesley Chapel, 1862

Since the introduction of classicism to Harrogate with the building of the Old Sulphur Well Temple in 1807–08, its use had increased considerably, especially in the area of public buildings, so when the burgeoning Wesleyan Methodist population began to consider a new chapel, it was hardly surprising that their architects came up with a classical frontage. What was startling was the splendid scale and overwhelmingly Roman appearance of the building designed by the well-established practice of Lockwood and Mawson. Located at the junction of Chapel Street and Cheltenham Crescent, Wesley Chapel had seats for nearly 1,000 people, but following the removal of the pews and their 2014 replacement with comfortable and moveable chairs, the number was reduced. Lockwood and Mawson's Italianate frontage consists of giant Corinthian half-columns and pilasters, with round-headed windows, all executed in good stone, solid testimony to the confidence of local Methodism at this period. The site's 1,584 square yards was bought from the Victoria Park Company for £316, the foundation

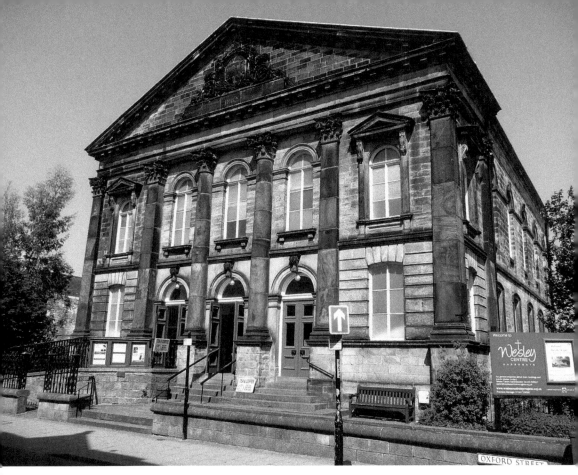

Wesley Chapel's splendidly confident frontage.

stone having been laid in 1861 and the building, which cost £4,281, opened on 3 October 1862. Today, in addition to its sacred role, Wesley Chapel also provides a venue for recitals by outstanding musicians that have become an important part of the community's cultural life.

17. Cambridge Crescent, 1868–73

Until 1860 and the creation of the Victoria Park Company, the present heart of Harrogate was nothing but agricultural land used by farmers to produce food for the hotels of High and Low Harrogate. But thanks to the vision of two men – the speculating builder George Dawson and the eminent architect J. H. Hirst of Bristol – a carefully planned series of developments provided the new single town with an attractive central square framed by imposing buildings. The first of these was Cambridge Crescent, which sweeps round the northern side of Prospect Square with a cleverly designed terrace of stone buildings, most of which have a south-facing frontage. Dawson acquired a 'pie slice' portion of 212 square yards of land from the Victoria Park Company in January 1868 on which the first unit

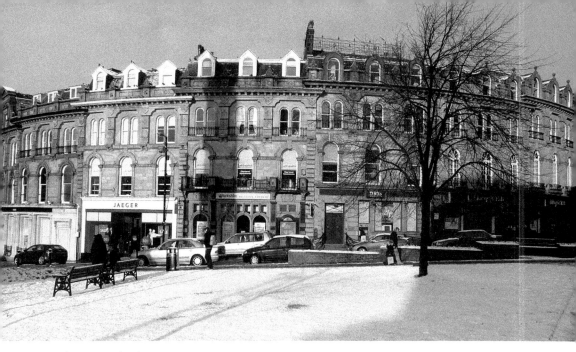

Above: Cambridge Crescent.

Below: Cambridge Crescent enjoying southern sunshine.

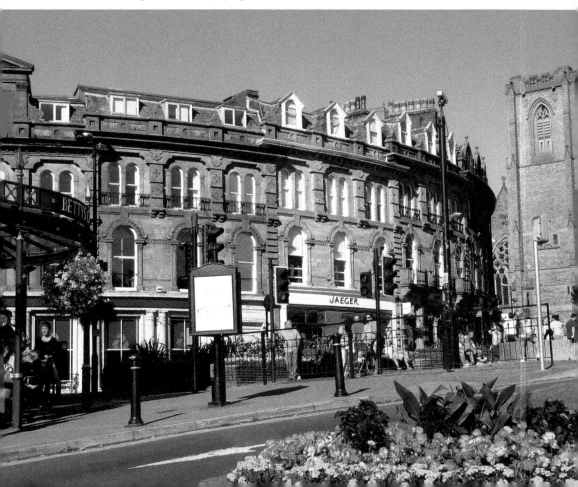

of Cambridge Crescent was built. As this crescent did not appear on the Victoria Park Company's first development plan, it must have been Dawson himself who decided to build a large crescent, employing the company architect to design it.

During 1868, the Improvement Commissioners twice refused Dawson permission to build on his new site, probably because the plans were inadequate, and the original building line was breached. Dawson, however, kept on building, and in August 1869 he was summoned to appear before the magistrates at Knaresborough, where he was fined the derisory sum of one shilling, with costs at 10s/6d! According to historian H. H. Walker, Dawson had in fact begun to build Cambridge Crescent as early as 1867, before he had even bought the site. With Cambridge Crescent almost finished, Dawson began his second great crescent on 1 December 1873, when his plans for Prospect Crescent were laid before the General Purposes committee on 1 December.

Dawson and Hirst seem to have intended the eastern units of the crescent (nearest St Peter's Church) as residential and those on the western section (nearest Parliament Street) as commercial, with much larger windows at ground-floor level. It says much for Hirst's ability that over the decades the various units have been used for a great variety of purposes without violating the architectural unity of the crescent, apart from alterations to the ground-floor windows. A particularly admirable quality of this fine piece of urban development is the way in which it occupies its steeply sloping site, in a gently stepped manner. Some of the units nearest Parliament Street also incorporate terracotta and mosaic embellishments, probably added at the behest of the original occupiers.

18. Nos 1–21 James Street, 1864–65

The Victoria Park Company, established in 1860 to link together High and Low Harrogate into one town, saw James Street as an important commercial thoroughfare, a concept that really took off in 1864 when Richard Ellis began to build a terrace of shops with living accommodation above between Station Parade and what later became Princes Street. It was said that when the new central railway station had opened in 1862, surrounded by little more than open fields, Ellis had seen the benefit of having an architecturally splendid entrance to the town that could be provided by a terrace of specially designed commercial property. He chose the great Bristol architect J. H. Hirst, with whom George Dawson was to have such a fruitful partnership, and before it was degraded and vandalised by later generations, Nos 1–21 James Street gave Harrogate its first example of a commercial building of real architectural magnificence.

Hirst introduced brick into the façade of his James Street frontage, mixing it with beautifully hand-cut massive masonry from local quarries, to produce a pleasing polychrome effect that was further enhanced by the range of huge round-headed windows whose repetition created rhythm that carried the eye along the

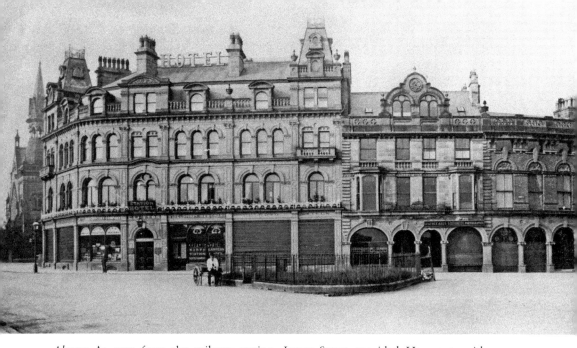

Above: As seen from the railway station, James Street provided Harrogate with an impressive entrance.

Below: Even in mutilated form, Ellis and Hirst's terrace is still impressive.

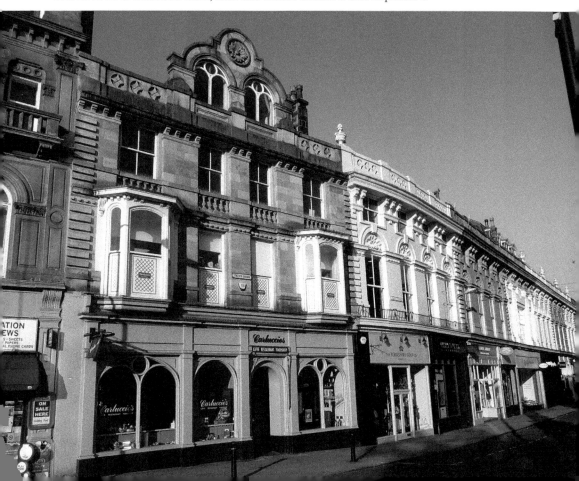

entire building line. The installation of detached marble columns between the ground-floor windows, and the use of round-headed doorcases that matched those of the windows, added to the terrace's lively appearance, whose impressiveness was emphasised by a particularly heavy cornice and balustrade enriched by great stone vases that added drama to the structure's silhouette. The westernmost unit of Hirst's terrace was occupied by the new post office, which displayed the royal arms over its curved entrance. In around 1900, a fishmonger ripped out the entire ground-floor frontage of his premises to provide an open fish counter, and thereafter other traders made alterations, so that by 1970 only one of Hirst's magnificent original frontages remained intact. Some traders introduced crass alterations to their upper windows; others daubed sections of their premises with paint that obscured the polychrome decoration. Today, the terrace is a sad ghost of a once magnificent building. But restoration remains a possibility, although it is unlikely to occur without intervention from the authorities.

19. Rogers' Almshouses, 1868

When the wealthy philanthropist George Rogers, of Park Parade's Claro Villas, decided to build a suit of almshouses in Harrogate, he purchased land from Nicholas Carter, paying Carter £1,422 for two contiguous plots that faced each other astride the new Avenue Place, later to be called Avenue Road and then Belford Place. On the western plot he built the elegant series of homes known to this day as Rogers Almshouses, the site to the west eventually being occupied by the Infirmary, later St Peter's School. The surrender of the site for the almshouses was dated 13 October 1866, and one month later, on 24 November 1866, Rogers enfranchised the land with the Duchy of Lancaster. Having acquired the site, Rogers then submitted a request to Harrogate's Improvement Commissioners for the construction of a road to link Avenue Place with Victoria Avenue. Work on the almshouses, which were designed by the distinguished Bradford firm of architects Andrews and Pepper, began in 1868. The design was for twelve almshouses built on three sides of a square open to the east. The domestic Gothic design contains several pleasing features, such as the strong corbel table, Gothic windows and a splendid pyramid-roofed clock tower rising from the centre of the eastern-facing block. This last is embellished by a sculpted beehive, emblematic of industry, and above this, the bust of George Rogers was placed in 1909 after being moved from its original position on a marble plinth in the front garden. George Rogers spent £4,000 on his charitable venture, which was funded by several wise investments that paid the charity enough to administer the almshouses and provide the carefully selected residents with a pension.

The selection criteria was typical of Victorian England: 'nine of these almshouses are intended for women, either widows or spinsters, who have moved in a respectable position in life, but who have been reduced to poverty

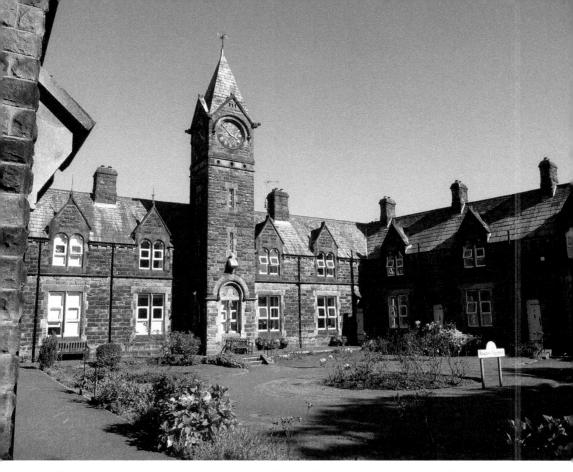

Rogers Almshouses of 1868 were designed by Bradford architects Andrews and Pepper.

by circumstances over which they had no control, and who have lived within three miles of Bradford Parish Church for three years immediately preceding their application, and have attained the age of sixty years. The other three houses are for similar persons, who have resided for three years within three miles of Christ's Church, Harrogate.' In building his twelve houses in this form, George Rogers provided Harrogate with one of its most useful and attractive architectural creations, which although diminished in 1940 by the removal of its splendid iron railings, is still a delight to the eye. Today, Rogers Almshouses are still homes, whose privacy should be respected.

2c. Ogden of Harrogate, 1870

In February 1870 George Dawson set about building in James Street, where once again he employed Bristol architect J. H. Hirst, whose 90-foot-long stone terrace in the Italian style was praised by the *Advertiser* as 'for beauty and effect will be unsurpassed by anything in Harrogate'. Today, the building does not show either Dawson or Hirst at their most magnificent, largely because later generations of

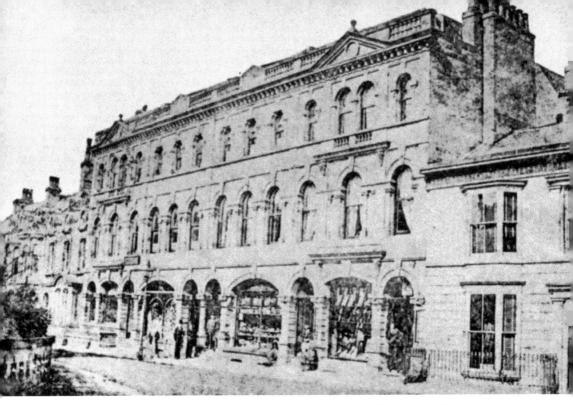

Hirst of Bristol's 1870 building before being partly occupied by J. R. Ogden.

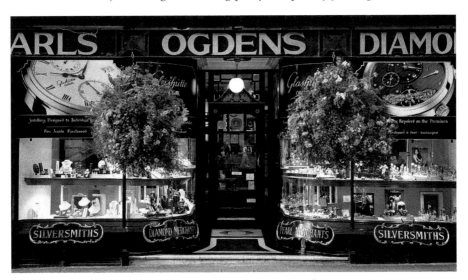

Ogden's fine Edwardian frontage.

retailers have ruined the ground-floor frontages by inserting characterless and modern plate-glass windows. An exception must, however, be made with Ogden's, whose frontage represents the best aspect of Edwardian alterations to a Victorian façade. It was James Roberts Ogden who founded the well-known jewellery firm of Ogden back in 1893 when he opened his premises in Cambridge Street, the success

of which enabled him to extend his premises several times until in 1910 he acquired No. 38 James Street, which was remodelled and provided with a splendid glass and iron canopy. In over 125 years of business, Ogden of Harrogate have been famous not only for their high standard of retailing jewellery, watches and clocks, silver and gold, and other fine and beautiful objects, but also for their customer service. In summer Ogden's frontage is gaily decked with hanging flower baskets.

21. St Peter's Church, 1870–1926

Shortly after the establishment of the Victoria Park Company in 1860, a movement started to encourage the building of a new Anglican Church in central Harrogate. This received powerful momentum when a site was donated that allowed for the erection of a church with an attached school, the school being the first to be built. In 1868, a subscription was begun for building the church, and by February architects were invited to submit plans. The following year the new parish came into being, which had largely been carved out of the parish of Christ Church. The commission to design St Peter's Church was awarded to J. H. Hirst, who had done wonderful work for both Richard Ellis and George Dawson, as well as the Victoria Park Company. Indeed, Hirst had initially proposed the site should have a church with a slender spire, but as the flanking Cambridge and Prospect crescents arose, it became clear that their great bulk called for a church with a much more dominating feature, and a 90-foot tower crowned with a 100-foot spire was added. After the foundation stone was laid on 21 April 1870, building

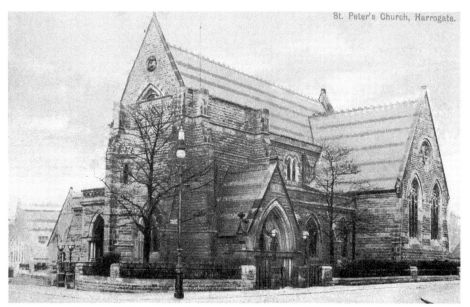

St Peter's Church stands proudly at the heart of Harrogate.

progressed so well that it was possible to open the chancel and temporary nave on 7 September 1871. The church was consecrated on 3 October 1876, by which time it was clear that Harrogate had received a notable addition to its legacy of sacred architecture. Further important additions were made in 1885, 1890, 1910, 1921 and 1926 when the great tower was completed to a design by A. A. Gibson, which respected Hirst's original concept while omitting the spire.

Internally, St Peter's contains much of beauty and high craftsmanship. The splendidly broad nave contains stone carving by Pashley, whose other work at Lichfield Cathedral is widely admired. The internationally celebrated organ builder Schultze constructed the first great organ to be installed, and also the second organ – after the first proved too big for St Peter's. But it is perhaps the stained and painted glass that is St Peter's greatest decorative glory, which is both rich and artistic. It was made by the famous London firm of Burlison and Grylls, and embellishes the chancel, transepts, chapel and aisles, and is a glorious sight. More recently, a splendid series of modern improvements were introduced to St Peter's exterior and interior between 2009 and 2011, which greatly enhanced the mission of this great church at the heart of the Harrogate community.

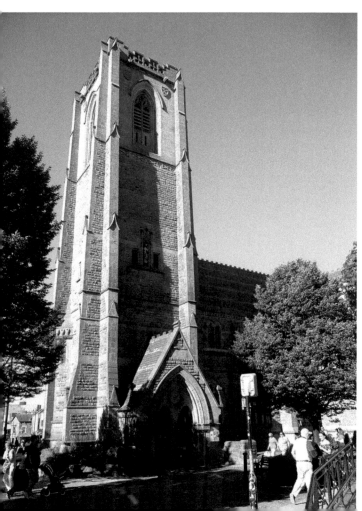

The tower was completed in 1926.

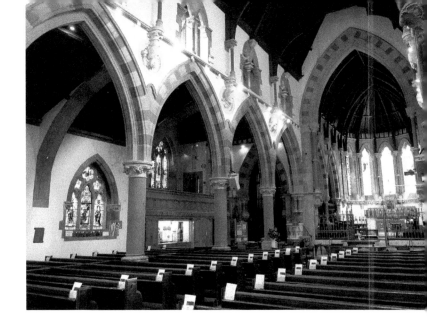

Part of the richly
decorated interior
of St Peter's.

22. Prospect Crescent, 1875–80

It is difficult to think of a building that has been more influential in determining
the layout of central Harrogate's commercial heart than Prospect Crescent, which,
along with its north-western neighbour Cambridge Crescent, determined the routes
of all of the town's principal shopping streets. George Dawson laid his plans for
Prospect Crescent before the General Purposes Committee on 1 December 1873.
Designed by architect J. H. Hirst, the crescent was intended to be built in stages, the
first unit being erected for the General Post Office in 1875 at the junction with James
Street. Plans for a further four sections were passed in 1876, but an application in
1878 for the final four units at the junction with Cambridge Street was refused,
although it must subsequently have been approved, as the last unit carries the date
1880 in the corner gable above the triumphant letters G. D. Prospect Crescent took
five years to build, and although Hirst had designed it when the land had been
owned by the Victoria Park Company, it was George Dawson, rather than the
Carter Brothers and Richard Ellis, who realised Hirst's vision. The new post office,
occupying the first unit, opened to the public on Friday 29 June 1875. During the
busy summer season Harrogate's mail averaged 52,000 letters per week, falling in
winter to around half that figure. There were 20,000 money order transactions and
38,000 telegrams received in the upstairs telegram room.

Prospect Crescent, which overlooks the Low Harrogate Valley so impressively,
is a massive pile of masonry with giant Corinthian pilasters running up the first
and second storeys and several canted bays, also in solid stone. Each extremity of
the crescent is crowned with a tall roof pavilion, similar to several others placed
on local buildings of that time. When seen in late afternoon or early evening, with
light from the setting sun illuminating its handsome frontage, Prospect Crescent
takes on the appearance of a mini Colosseum. It is, however, a thousand pities that

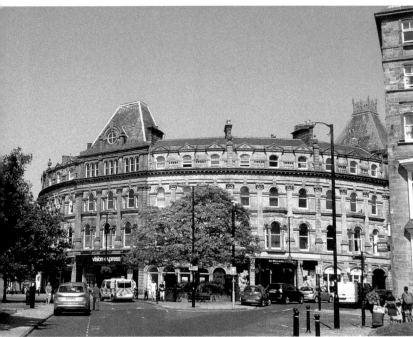

Above: Prospect Crescent *c.* 1920, before the building of the war memorial.

Left: Prospect Crescent's massive masonry looks best in sunlight.

after the First World War, a series of alterations to the ground-floor commercial premises destroyed all save one of the magnificently florid façades created by builder George Dawson and architect J. H. Hirst.

23. Grosvenor Buildings, 1875

The massive stone block of Grosvenor Buildings is usually passed without a second glance from the pedestrian as its fronting pavement is often busy, the road crowded with passing traffic, and good views of the frontage are really available only from across Crescent Gardens. But that said, it is worth taking a moment to examine the handsome architectural design of the terrace that forms such an imposing framework to the southern boundary of Crescent Gardens. The basic facts about Grosvenor Buildings are that they were built to plans of George Dawson in two stages. Nos 18–24 nearest to the Royal Baths were erected after December 1874 to a design by J. H. Hirst of Bristol and have a series of magnificent round-headed windows running along the ground and top floors. The façade is embellished with deeply rusticated masonry with boldly carved urns crowning the cornice balustrade. This is Victorian confidence at its expressive best. By 1884, the Grosvenor Hotel had established itself here. Stage two of the development occurred after January 1884, when Dawson built Crown Place Nos 1–3 and Crescent Road Nos 2, 4 & 6, one of his most purely beautiful creations, which gave Crown Place and the Royal Pump Room a magnificent backdrop, hinting at the work of Borromini. Again, J. H. Hirst was the architect. Stage three, which completed the gap between Nos 6 and 18/22 was built after Dawson's death by his executors, who employed another architect who, regrettably, abandoned Hirst's wonderful design for a much safer and conventional one.

Grosvenor Buildings in Crescent Gardens.

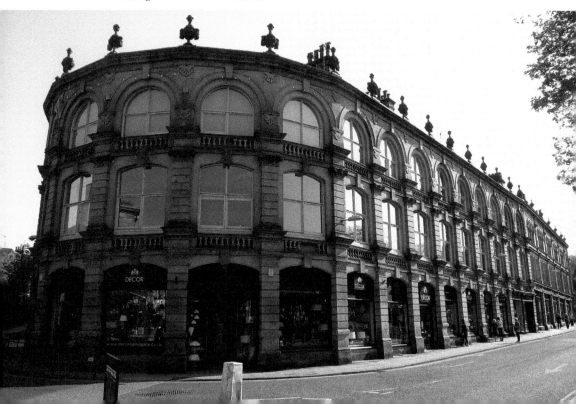

Grosvenor Buildings in Crown Place.

There is circumstantial evidence to show that Grosvenor Buildings had originally been intended for the opposite side of Crescent Road, the land of the old Crescent estate having been snapped up by George Dawson. The site was critical to the success of the New Victoria Baths built in 1870–71 by the Harrogate Improvement Commissioners. Their failure to secure the site and Dawson's subsequent threat to build a large new hotel on his newly acquired land with its back to the new baths was unfortunate. A back view meant that instead of overlooking a pleasant green open space, the baths would face delivery yards, stables and muck-heaps. Eventually the commissioners had to pay Dawson handsomely for the site, to the fury of the ratepayers.

24. The Club, 1885–86

Perhaps Harrogate's least-known treasure, The Club, once known as the Gentlemen's Club but today as the Harrogate Club, stands imperiously at No. 36 Victoria Avenue, its superb frontage seemingly a contradiction of the institution's modern and welcoming character. Outside, an essay in high Victorian exclusiveness, with a raised ground floor reached by a mountain of wide stone steps, and a massive front door flanked by a pair of the finest curved glass windows in Yorkshire. Inside, a welcoming warmth, friendliness, sociability, fine catering, fellowship and good will, all of which have been greatly enhanced by the increasing numbers of women and young professional business people who are flocking to join the organisation that is Harrogate's oldest establishment after the Church of England. It was back in 1857 that a group of local men, mostly doctors, solicitors and hoteliers, founded The Club in premises on Devonshire

Above: The Harrogate Club's impressive exterior.

Below: Fine dining at the Harrogate Club.

A members luxurious lounge in the Harrogate Club.

Place where they could meet to discuss local and national affairs, read newspapers and journals, play billiards, and generally socialise in agreeable surroundings. The Club flourished so much that by the 1880s the committee decided to erect a custom-built structure in the rapidly developing locality of Victoria Avenue, commissioning the Bowns, a successful family of architects, to design a noble building that would be a landmark in the town. When the new Club building opened in March 1886 it was obvious that the Bowns had fulfilled their client's aspirations magnificently. In those days, The Club maintained a steward, who lived in the basement flat below The Club, which today is hired out to a private business company, the Steward's position having been replaced by a manager, who, together with her staff, maintain high standards of catering. After passing into the entrance hall with its lofty staircase, illuminated by a huge window of beautiful painted glass, the visitor encounters two lofty rooms, one The Club's members lounge, originally known as the reading room, and the other the Dining Room, which is also used by Bridge players and to accommodate the many presentations and talks arranged by The Club's social committee. State-of-the-art kitchens, and a separate bar complete the ground-floor facilities. The first floor has two enormous rooms, one – a gloriously restored upper lounge – offers, from the luxurious comfort of its great bay window, a fine view of Victoria Avenue. The other room, the largest in The Club, is the great chamber for billiards and snooker, its high glass ceiling carried aloft with wonderful wooden trusses in the Gothic style. The Club's visitor's book records that Sir Arthur Conan Doyle, creator of Sherlock Holmes, played a game here and where, according to local rumour, he also attended a séance.

The Club also displays paintings from the Municipal Mercer Art Gallery and some silver from the Municipal Collection, further interesting objects being lent by the Yorkshire Regiment with whom The Club has close ties. All these artefacts are shown to the general public regularly, thanks to The Club's participation in the guided tours provided for Heritage Open Day. With all these positive sides to its activities, it is hardly surprising that at the time of writing the Harrogate Club's membership is at an all-time high.

25. Grove House, Eighteenth Century and 1890s

Grove House, famed during the nineteenth century as Samson Fox's home and during much of the twentieth century as the northern convalescent home of the Royal Antediluvian Order of Buffaloes, has a far longer history. The central 'core' section can be dated back to the late 1740s, when it replaced an earlier structure from the reign of Charles II, probably *c.* 1660 when it was the World's End Inn, a name that had widespread usage after the execution of Charles I in 1649. The eighteenth-century 'core' building was drawn in *c.* 1833 by an artist some believed to have been the great W. P. Frith. This shows the massive cube-like stone block of three storeys and five bays on World's End Road before the impressive wings and porte cochère were added by Samson Fox between 1890 and 1900.

It was as an Inn that the World's End featured in the memoirs of Blind Jack Metcalf, the Yorkshire Road Maker, who in 1739 eloped with Dolly Benson, daughter of the landlord of the Granby Hotel. The horses used for the elopement were obtained through the good graces of an ostler at the World's End. The World's End Inn appears to have closed some time near the end of the eighteenth century, after which it became a school, adopting the name of The Grove. This was eventually leased by Barbara Hoole, also known as Barbara Hofland, the celebrated authoress of *A Season at Harrogate*, published to wide acclaim in 1811. Thereafter, the old building was used for a variety of purposes, generally residential, until it was acquired in 1882 by the great industrialist and inventor Samson Fox, whose architect, T. Butler-Wilson, added flanking wings, a massive stone porte cochère and much heavy crenellation. Internally, Grove House was

This drawing of *c.* 1833 shows Grove House without its wings.

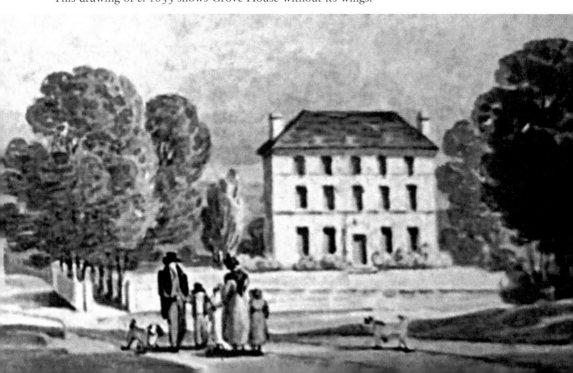

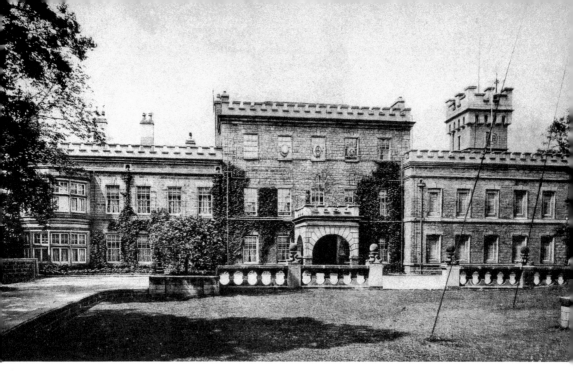

Grove House after Samson Fox's extensions.

enriched with several impressive staterooms, a gallery, and fine painted and stained glass, although after Samson Fox's death in 1903 many alterations were made, especially during the First World War when it was an Auxiliary Military Hospital, and after 1927 when it was bought by the RAOB. At the time of writing, Grove House has been acquired by Springfield Healthcare for conversion into a centre for the reception of older residents in need of health care where particular attention will be given to the avoidance of social isolation by inter-generational integration. Springfield Healthcare will do this by encouraging local schools and other organisations to enjoy various activities in the estate's beautifully spacious and newly landscaped gardens, bringing a real community feel to the environment. In turn, the schoolchildren will be actively encouraged to participate in the daily lives of the residents, bringing great benefits to all parties.

26. Nos 1–4 Springfield Avenue, 1893

In April 1892, the council asked to inspect plans for the Spring Bank estate, on which the Hotel Majestic and surrounding residential streets would eventually be built. These streets included Springfield Avenue, Coppice Drive, Spring Mount and Spring Grove. According to the Broadbank Survey of Harrogate's houses, by 1901 Springfield Avenue had six houses, Coppice Drive had five houses, and neither Spring Mount nor Spring Grove had any houses. Although Springfield Avenue had only six properties by 1900, these were of an exceptionally high architectural and structural quality, forming an attractive enclave of neo-Tudorism in an area

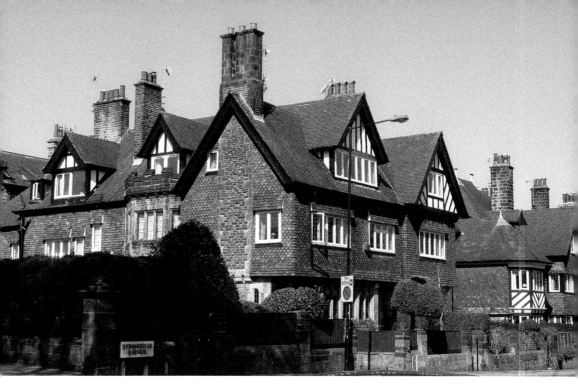

These beautifully designed properties have fine Arts and Crafts detailing.

of otherwise solid but plain Victorian masonry. Nos 1 and 2 Springfield Avenue, the work of Leeds architect Edward Hogshaw, are impressive by any standards, having tile hangings, a castellated stone bay and lavish black and white timbering, the whole ensemble being a joy for the eye. This continues with Nos 3 and 4 by the same Hogshaw, who obviously had a fine eye for the picturesque (they were to be joined in 1902 by Nos 5 and 6, built in the same style by Samuel Stead of Harrogate). Nos 1–4 all date from 1893. Further along Springfield Avenue, Nos 7 and 8, designed by H. & E. Bown, date from 1898 and show the same strong neo-Tudor influences as their western neighbours.

27. New Magnesia Well Café, 1895

One of the prettiest pump rooms of Victorian England, the Magnesia Well Pump Room dispensed one of Harrogate's most popular mineral waters. This popularity with townspeople and visitors alike was probably because its mild nature and proven diuretic qualities made the Magnesia Water more palatable than the more offensively smelling and strong sulphur waters. In 1858, a little Gothic-style pump room was built to shelter the Magnesia Well's visitors, which proved so popular that in 1890 instructions were issued for the design of a new pump room, to supply not only Magnesia Water, but also sulphur water from the important Well No. 36. Opened in 1895, with ironwork supplied by Lockerbie and Wilkinson, the new pump room replaced the earlier 'Gothic' Magnesia Well Pump Room, which

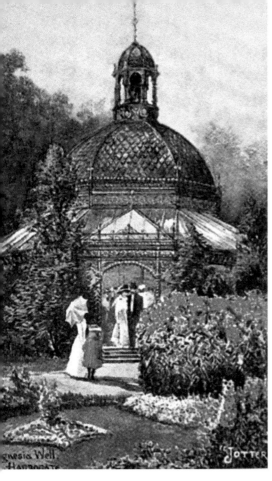

Left: An Edwardian postcard of the popular
New Magnesia Well Pump Room.

Below: Today, the New Magnesia Pump Room
is a popular café.

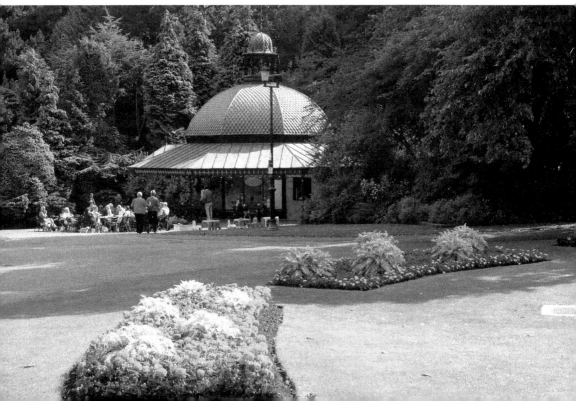

was subsequently used for various purposes, including a home for the Harrogate Museum and a store for the gardener's tools. The new pump room was built on an octagonal ground plan, crowned with a handsome domed and copper-tiled roof, and fringed by an encircling glazed veranda on which tables and chairs could be placed. Opposite the New Magnesia Well Pump Room, a bandstand was also opened in 1895 and also built on an octagonal ground plan. Its open encircling railings ensured that performances could be seen and heard for 360 degrees round the building, which conformed to the Victorian view that music was a life-enhancing experience and thus a positive complement to the benefit of the gardens. In 1933 however, it was removed and replaced by an enclosed structure that directed music only towards the seats available on payment of an entry fee. The lovely pump room, however, survived, and today is occupied by a delightful café, which in summer is gaily decked with gorgeous hanging baskets.

28. The Chapel, Grove Road, 1896–97

Now one of the most extraordinary homes in the UK, The Chapel is a converted Methodist Church that was built between 1896 and 1897 on the Grove Road estate, which had been developing since the 1870s. The local population of Wesleyan Methodists put up a building in 1892 that was used both as a school and a chapel, the success of which led them in 1894 to begin to build a much larger chapel on land adjoining the school. Architect W. J. Morley designed the

The beautifully restored exterior of the Grove Road Chapel.

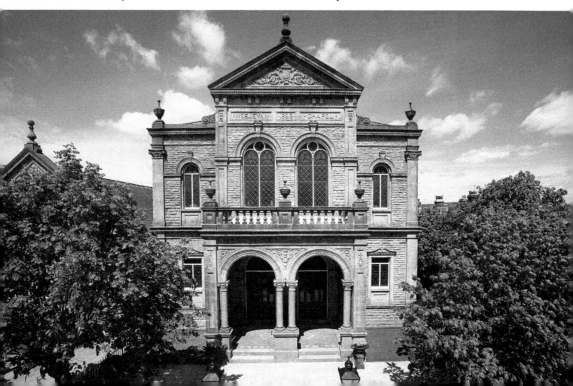

new building as a galleried chapel in the Italian Renaissance style of architecture, the sophistication of which provided the town with a handsome addition to its architectural heritage. After laying the foundation stone on 18 May 1896, work progressed quickly, the building being opened on 8 June 1897 when it had accommodation for a congregation of 700, most of whom must have been deeply impressed by the superb quality of masonry work (largely rusticated sandstone), the outstanding carpentry and the dazzlingly beautiful stained glass by Lazenby of Bradford. The Chapel received a fine Harrison and Harrison organ in 1901, which in November 1934 was praised by no less than Albert Schweitzer.

A century after its opening, the Grade II-listed Grove Road Methodist Chapel's congregation was dwindling, so the decision was taken to close as a place of worship. The Italianate building, along with the adjoining former Sunday school, was acquired by businessman and art connoisseur Mark Hinchliffe, who began converting the buildings into two separate dwellings. The project opened with the sympathetic conversion of the former Sunday school into a contemporary modern living space. The proceeds of this enabled Mr Hinchliffe to embark on the greater task of converting the former chapel into a home to contain his considerable collection of fine art and antiques, and also a boutique bed and breakfast with

The spectacular interior contains a wealth of Arts and Crafts objects.

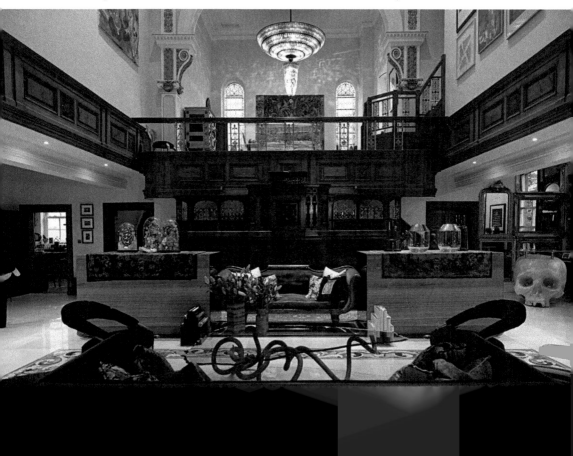

curated guest rooms. The completion of this work in 2017 has been a superlative success, in that a fine old building has been magnificently restored and given new life. Mark Hinchliffe's collection includes objects from every conceivable geographic location, every human cultural epoch, and skills from the sublime to the naïve. There is a distinct sense of passion here at The Chapel – in the collections and in the architecture – a passion that is invariably shared by visitors to this unique place, which can be hired as a venue for weddings, receptions, filming, conferences, corporate hospitality and bed and breakfast accommodation.

29. The Royal Baths, 1897

Perhaps the greatest of nineteenth-century England's spa buildings, the Royal Baths was conceived as the culmination of Harrogate's attempts to become the premier spa. Before it was built, the town's principal municipal spa building was the New Victoria Baths of 1871, which occupied what later became the council offices. This had been the brainchild of Richard Ellis, who, towards the end of his life, envisioned an even greater spa building that would be home to the greatest range of medically approved spa treatments in the world. The site between Parliament Street, the Crown Hotel and Crescent Road presented considerable difficulties for competing architects, in that it had to be an impressive building at the foot of a hill, which by reason of the often frail condition of patients, necessitated it having no upper floors. In response, the winners of the competition, Messrs Baggallay and

The impressive Royal Baths building.

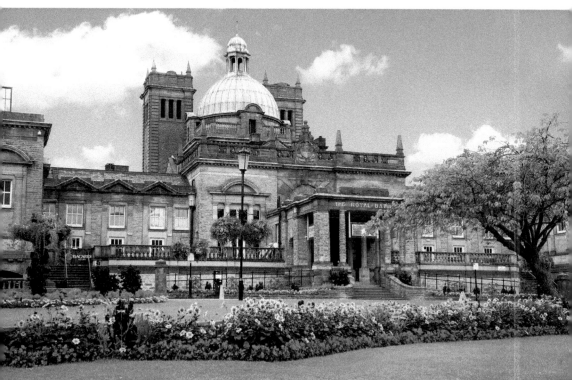

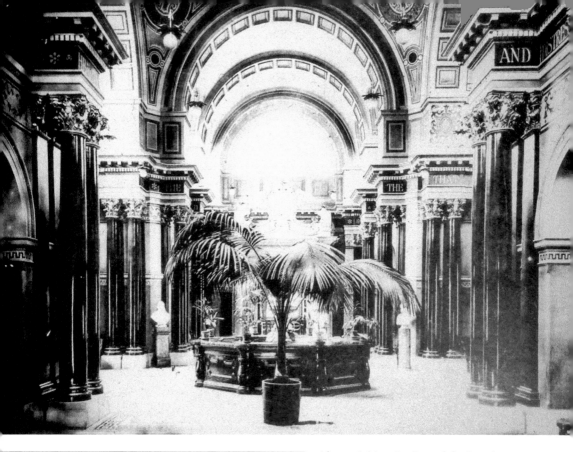

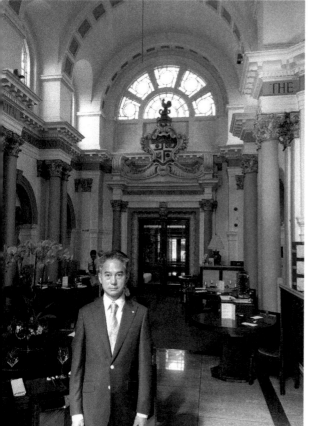

Above: A historic view of the Royal Baths Grand Pump Room.

Left: Restaurateur Hak Ng in his superb Chinese restaurant within the Royal Baths.

Bristowe, produced a single-storey main building set atop a basement plinth not used by the public, height being provided by two water towers to provide pressure for the bathing treatments, and a mighty dome over the central Grand Pump Room. When HRH the Duke of Cambridge opened it on 23 July 1897, the Royal Baths was home to dozens of specialised medical spa treatments, its golden age lasting from 1897 until the 1930s when fashions began to change. Following the birth of the National Health Service in 1947, and new attitudes to spa treatments, the Royal Baths struggled until 1969, when it closed as a spa, save for the ever-popular Turkish Baths, the oriental splendour of which has to be seen to be believed.

After decades of underuse, new life was introduced to the Royal Baths in 2008 when successful restaurateurs Hak and Monika Ng spotted its potential and leased the former Grand Pump Room and associated areas, which they restored expertly and lovingly to contain the superb Chinese restaurant they then opened. The state-of-the-art kitchens are open to view, which is always a good sign in a restaurant, and several of the old treatment areas are now magnificent private dining rooms. Visitors entering the Royal Baths Chinese Restaurant for the first time should not be so dazzled by the magnificence of the interior that they are made to believe the cuisine is secondary. It is not. In fact, it is the author's opinion that no better Chinese cuisine can be found anywhere, and certainly not in the United Kingdom. That it can be enjoyed beneath the great coffered dome of the former Grand Pump Room, with its lovely stained-glass windows, soaring columns with their unique dolphin capitals, and inscriptions from the poetry of James Thomson and James Montgomery, is a decided bonus. No visit to Harrogate is complete without experiencing the unique Royal Baths Chinese Restaurant.

30. Westminster Arcade, 1898

Westminster Arcade is Harrogate's quintessential Victorian building, even before you get to the architecture. It was planned in 1897, the year of Queen Victoria's Diamond Jubilee and of the opening of the Royal Baths. It was designed by Whitehead and Smetham, who were responsible for the majority of villas on the Duchy Estate. It was built by Alderman David Simpson, the thrice-mayor, who developed the Duchy Estate and laid the foundation stone of the Royal Hall. It was financed at a lean time in the local building trade to provide masons and sculptors with employment. It was conceived as an improvement to the appearance and retailing facilities of Parliament Street – all very Victorian ideals. Building work began in January 1898 with the demolition of Dr DeVille's house and the clearing of the site, and progressed throughout the year until completion in November. Named the Royal Arcade, the three-storey building provided a public walkway from Parliament Street through to Union Street, lined with shops and with the town's most flamboyant frontage, often photographed by startled passers-by. This has a Gothic tower embellished with bartizans and a spire, over which crawl dragons. Absolutely splendid!

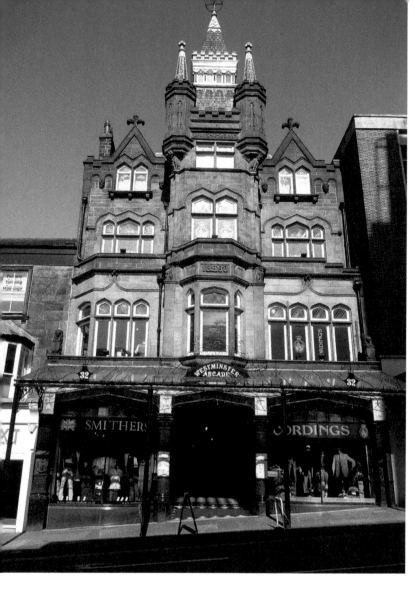

The Westminster Arcade's eye-catching façade.

31. Bettys, 1900

Sometimes described as being in the Scottish Baronial style of architecture, the building that today contains Bettys Café was very much a product of 1900, the date featuring on the structure's Parliament Street frontage in finely carved stone. Built at almost the same time as the Westminster Arcade further down Parliament Street, the new building, standing prominently at the junction of Parliament Street and Montpellier, replaced the much older Hopewell House, which for many years had been occupied by members of the medical profession. The first occupant of the new building was the Café Ophir, but when the business was acquired in 1905 by the famous tea buyer Taylors, the name changed to the Café Imperial, which became one of Harrogate's most celebrated cafés. The 1907 arrival in Yorkshire of

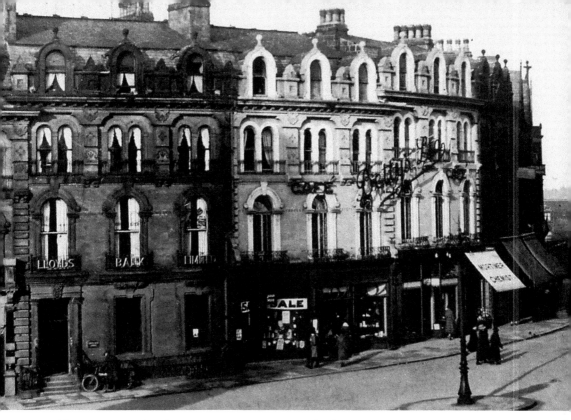

Above: Bettys' original Harrogate premises on Cambridge Crescent.

Below: Bettys' Parliament Street premises.

Fritz Buetzer was to prove highly influential for the direction of the county's café life. This twenty-two-year-old son of a Swiss master baker had great ambitions to become a chocolatier, and after gaining experience he moved to Harrogate in 1919 where he opened a beautifully fitted-out café on 17 July at Cambridge Crescent, changing his name to Frederick Belmont. The new café was called 'Bettys', which rapidly became popular, but explanations of why this name was chosen are varied. In 1962, Bettys acquired the older C. E. Taylor and Co. business, and in the following decade, the Café Imperial was closed, and Bettys moved from their old Cambridge Crescent address into the refurbished premises of the former Café Imperial, where they remain at the time of writing. Although Bettys displays are famed for their ingenuity and attractiveness, the pedestrian should not fail to examine the building's upper façades, which for a building of 1900 exhibit a remarkably high proportion of window to wall, as well as an unusual turret clock.

32. Harrogate Theatre, 1899–1900

Until the opening of the new central railway station in 1862, Harrogate was almost entirely built of stone. However, Thomas Prosser's railway station showed that important public buildings could indeed be built with brick, and during the 1870s there were several interesting examples of such constructional work done in the town, many of which experimented with the then fashionable Pease's white brick, also known as Scarborough brick. Thereafter there was a gap, until in 1900

An early colour postcard of what used to be known as the Grand Opera House.

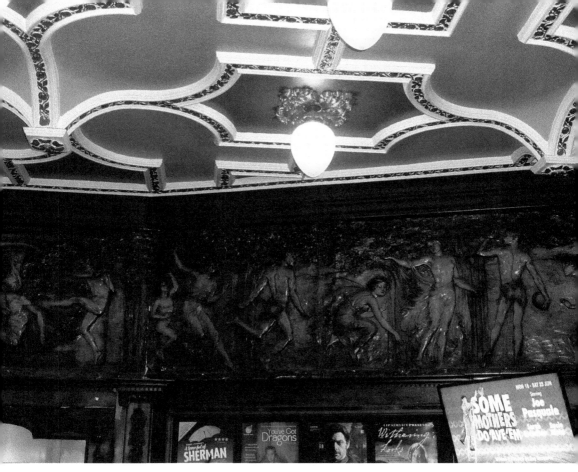

This splendid Arts and Crafts frieze in the lobby is by Francis Darlington.

a perfect rash of buildings were constructed with red brick including the huge Hotel Majestic and the 'Grand Opera House'. On 23 March 1898, the *Harrogate Advertiser* carried an advertisement for 'a fine corner business site in Chapel (later Oxford) Street and Cheltenham Parade, containing 715 square yards', and described as 'probably the finest remaining business site in Harrogate'. It was bought by William Peacock, who became managing director of the company that ran the Grand Opera House he built on the site. His architect was F. A. Tugwell, who designed a building that completely filled the triangular site, with a façade of brick with stone dressings. The interior of the new theatre had stalls and two circles, with a holding capacity of 1,300. The 71-foot-wide, 28-foot-deep stage was framed by a proscenium arch with a 26-foot opening. Embellished with elaborate fibrous plaster mouldings decorated with over 1,000 leaves of gold leaf, and several Arts and Crafts features, the new theatre had nine dressing rooms. Within, the main lobby is fringed with an unusual and rather wonderful frieze in relief by Francis Darlington, added a few years after the building's opening. In all, Harrogate Theatre, as it is now known, is a delightful example of a late Victorian theatre of modest dimensions.

Today's theatre is at the heart of the district's entertainment facilities.

The theatre's exterior was ringed by eight shops, once protected by a cantilevered canopy of iron and glass, each shop having good business frontages to either Chapel Street or Cheltenham Parade. The new Grand Opera House was opened by the mayor of Harrogate, Mrs James Myrtle, on Saturday 13 January 1900, after which it became the town's principal site of dramatic entertainment, a role it continues to fulfil to this day despite difficult periods in the 1950s, 1960s and 1970s when it was nearly lost. A major refurbishment of the mid-1970s brought seating in the main auditorium down to 500. Famous names to have appeared here include Sarah Bernhardt, Mrs Patrick Campbell, Charlie Chaplin, Ivor Novello, Sonia Dresdel, Trevor Howard, George Robey, Ellen Terry, Arnold Ridley, Pat Phoenix and Ken Dodd.

33. Hotel Majestic, 1899–1900

Dominating the valley of Low Harrogate and visible from beyond the town's built-up boundaries, the Hotel Majestic is well named. By the late nineteenth century, the town's enviable position as a fashionable rendezvous made it an obvious location for one of Frederick Hotels Ltd's greatest ventures, the company commissioning architect G. D. Martin to design something splendid. Something of the company's haste may been gathered from the fact that it had been intended to construct the Majestic with stone, but a masons' strike convinced the Board that brick was an acceptable alternative, although stone was used for the basement and ground-floor levels. The great dome is the building's single most striking architectural feature, although the great 8,000-square foot Winter Garden, the largest in the north of England, came a close second. Sadly this second feature was destroyed during the Second World War during a bombing raid of 12 September 1940. Some twenty years earlier, the Majestic had lost another important feature

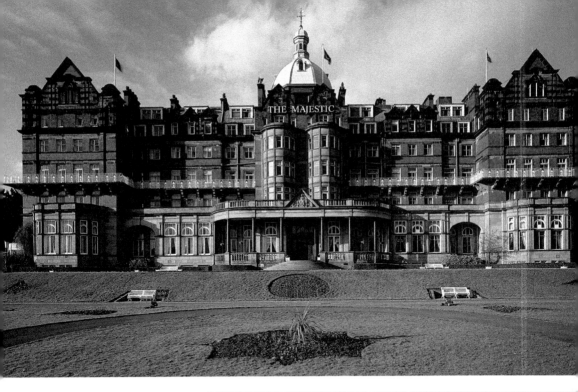

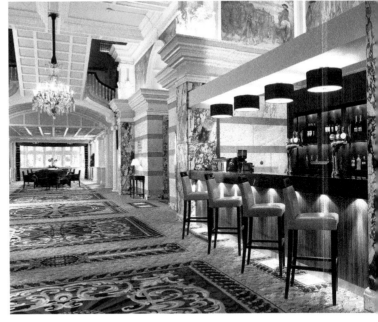

Above: The Majestic's great dome towers over Low Harrogate.

Right: Luxurious public rooms echo Edwardian opulence.

during a serious fire in 1924, which destroyed the amazing smoking room that had been built around fittings from the palace of Arabi Pasha, defeated by Sir Garnett Wolsey in 1882. The Majestic's series of enormous and magnificent reception rooms still remain to attest to the original intention that the hotel should be like a 'nobleman's residence'. Visitors should not fail to inspect the attractive series of

murals around the walls of the Great Lounge, which depict life in British spas – Bath, Buxton, Cheltenham, Hampstead, Royal Leamington Spa, Matlock, Royal Tunbridge Wells and Harrogate. When it opened on 18 July 1900, Harrogate had gained one of its greatest and most impressive hotels. At the time of writing, the Hotel Majestic had been acquired by Hilton's DoubleTree group of hotels.

34. Royal Hall, 1902–33

Harrogate's gorgeous Royal Hall, built in 1902–03 as the Kursaal, is the nation's last surviving intact Kursaal, a building type erected before the First World War to emulate those at the celebrated continental resorts. It is also the only Kursaal ever worked on by the great Frank Matcham, perhaps this country's best theatrical designer since Inigo Jones. One of the most remarkable facts about the Royal Hall was that the decision to build it occurred only one year after the council had opened their hugely expensive Royal Baths in 1897, which were unquestionably the most advanced centre for hydrotherapy in Europe. This was because the Kursaal was considered to be an essential attribute of the 'cure', in that the Royal Baths treated physical afflictions, by way of the mineral water regime, whereas the Kursaal (or 'Cure Hall') treated mental afflictions such as stress or

The Royal Hall.

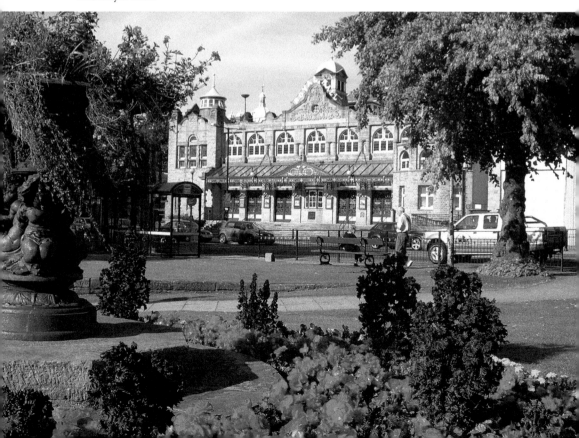

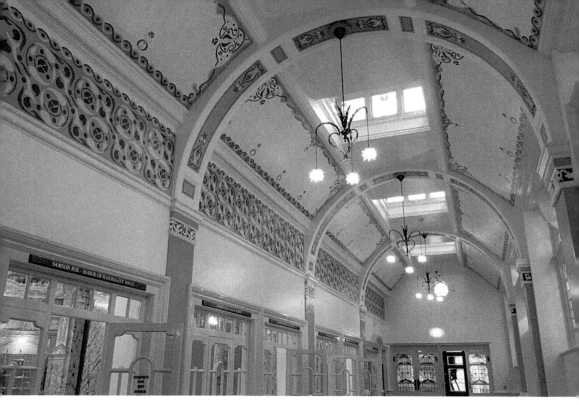

Above: The Ambulatory enabled visitors to exercise indoors.

Right: 'A palace of glittering gold'.

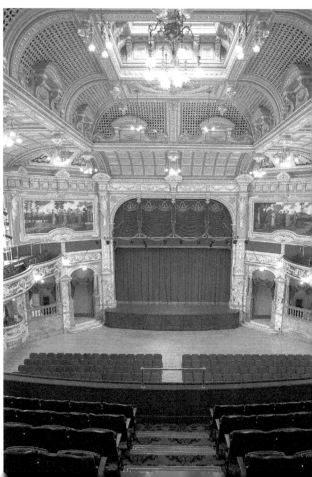

anxiety through entertainment, art and enjoyment. Consequently spa visitors first experienced treatment at the Royal Baths before crossing to the Kursaal for the relief of stress through the programmes at the Kursaal, which was renamed Royal Hall in 1919. A competition in 1899 saw the entry of Westminster architect Robert Beale winning, the assessor being Frank Matcham, who then worked with Beale to refine and improve the designs. The basic concept was for a beautiful central hall that could be adapted for balls, displays and ceremonials by means of the seats in the main arena being removable. An encircling ambulatory, or broad promenade, ensured that visitors wanting to exercise in bad weather had plenty of space to do so indoors. On fine days, the Kursaal's magnificent wooded gardens and lawns provided a magical backdrop against which the gilded elite of the times could perform their elaborate social rituals. And everywhere there was music.

The Royal Hall's breathtaking interior is a symphony of creams and gold, colour being provided by the rich burgundy drapes and seating covers, the stained-glass windows, the murals and coats of arms that flank the splendid proscenium arch. This stunning interior was restored from 2006–2008, work that included 112,000 sheets of 23.5 carat gold leaf and 57,000 man hours. It was opened by HRH the Prince of Wales on 22 January 2008. If any building in Harrogate deserves the status of a Grade I monument this does.

35. Windsor House, 1902–03

Today, this enormous building is known as Windsor House, but it was built in 1903 as Harrogate's Grand Hotel, partly to rival the luxurious Hotel Majestic, which had opened in 1900. The idea seems to have sprung from the fertile mind of Alderman David Simpson, whose development of the Duchy Estate had a profound effect on Harrogate's northern areas. With the National Provincial Development Company as his financial backer, David Simpson bought up seven smaller leases of land between Cornwall and York Road, and instructed his architects, Messrs Whitehead & Smetham, to produce something handsome. The resulting design showed that despite the many superb villas the partnership produced, a much larger hotel was a real challenge, as their plans resulted in a somewhat featureless stone cliff of a building built around a central winter garden, which could be guaranteed to get little sunshine. Because the Hotel Majestic, which had a stupendous winter garden, was crowned with a great dome, the newer Grand Hotel would have eight domes covered in reflective gold leaf, and each perched atop a narrow tower placed at strategic intervals around the building's façades. Whitehead and Smetham's principle design failing was that the hotel's main entrance was singularly unimpressive, even when the introductory screen of massive marble columns with their magnificent Corinthian capitals is taken into account. Internally, the hotel had many splendid public rooms, the *Harrogate Herald* reporting that it '...Has about 280 rooms ... the ballroom is of such proportions and magnificence as

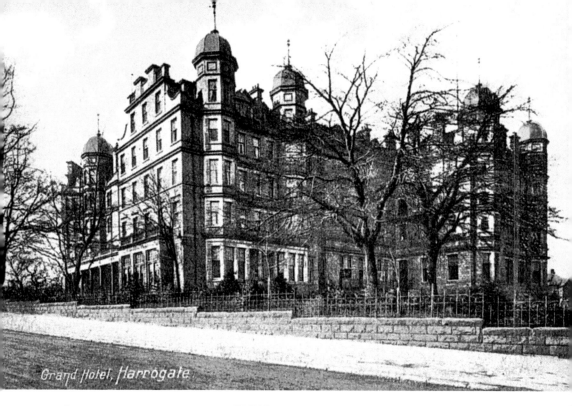

Grand Hotel, Harrogate

Above: A contemporary postcard of the Grand Hotel.

Right: A Grand Hotel interior, c. 1905.

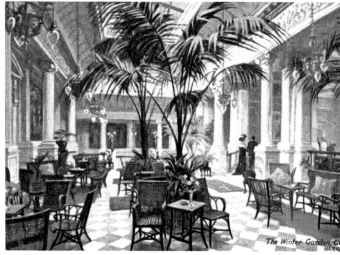

The Winter Garden, Gr
HARR

to be unequalled in Harrogate … today special saloons will leave London and Birmingham bringing large contingents of press representatives…'

During the First World War, the Grand Hotel was used to house the Furness Convalescent Home for Officers, one of whom was J. R. R. Tolkien, and during the Second World War it was requisitioned by the government and filled with various branches of state and defence, including the WAAF. The Grand reopened as a hotel in 1946, but went into receivership in 1954, the building thereafter being converted for office use, the name Windsor House then being adopted.

Windsor House embellishes Harrogate's skyline.

Although the once lavish interiors are no longer open for public inspection, the building serves a valuable purpose as an embellishment to Harrogate's skyline, the two best positions to view it being within Valley Gardens or beneath Queen Victoria's monument at the eastern end of James Street, where the vista is closed most effectively by the towers and domes of the former Grand Hotel.

36. The Gables, 1903–04

Situated on the St James' Park estate, The Gables is one of Harrogate's finest Arts and Crafts houses. The St James' Park estate to the south of the south Stray and the east of the railway line that bisects the old Paley estate was a product of the optimism of the brief period between 1900 and the First World War, when it was still possible to plan an estate of very large houses for very rich people and also a massive hydropathic establishment. The estate's plans were approved in November 1900, but by the outbreak of war in 1914 only a handful of the intended mansions had been built, including Courtfield, Holly Court and The Gables. Although the company's architect was Samuel Stead, individual clients could choose their own architects, and when The Gables was conceived as a house for Henry Angelo Holmes, the distinguished partnership of Parker and Unwin was contracted to produce a design. The year before Barry Parker and Raymond Unwin began The Gables they had prepared designs for New Earswick's garden

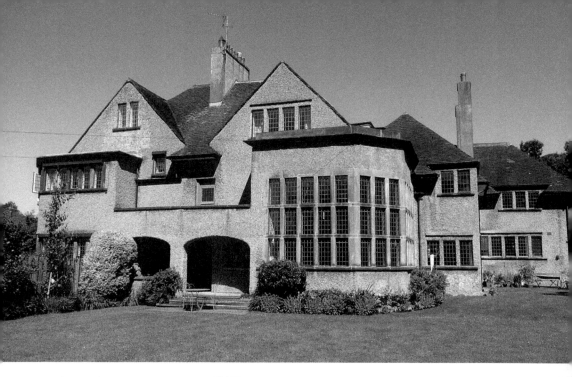

Above: The Gables from the garden.

Right: Interior of the Gables, *c.* 1905. (© Courtesy of Garden City Collection)

village for Rowntrees of York, and in 1903 they realised Ebenezer Howard's dream for a garden city at Letchworth – the first such community in the world. The success of this led to Parker and Unwin opening an office for their practice at Hampstead in London, after which Unwin began to plan Hampstead Garden suburb, for which work began in 1907. All this work was hugely influential, the partnership becoming a highly fashionable one. The Gables was built between 1903 and 1904 and incorporated several features made popular by Sir Edwin Lutyens, such as the handsome mullioned window over the double-height galleried

living hall, which may remind the viewer of Deanery Garden at Sonning. Today, The Gables is divided into two private residences, Grey Gables and Grey Garth, which contain a wealth of fine Arts and Crafts detail. Although they are not open for public inspection, a good impression of their exterior can be obtained from Cavendish Avenue. This long multi-gabled and rough-cast building, standing almost opposite Holly Court, is one of the most interesting in Harrogate.

37. St Wilfrid's Church, 1906–34

On 4 December 1901 the Duchy of Lancaster's surveyor wrote to the chancellor to express his concern that seven years had passed since the Duchy had offered a site for a new church on the residential estate being developed by Alderman David Simpson and others. This seems to have stimulated local movement towards its provision, and on 24 August 1902 a temporary iron church was opened for worship on Duchy Road. Following various private donations and the sudden death of a visitor to Harrogate in 1902, work was able to proceed on a permanent building, which would be called St Wilfrid's Church. The chosen architect was Temple Lushington Moore, one of the nation's most eminent ecclesiastical designers, who was commissioned in 1903 to produce plans for a church to accommodate 900 worshippers, but excluding a tower and spire, which would be completed at a later

St Wilfrid's Church.

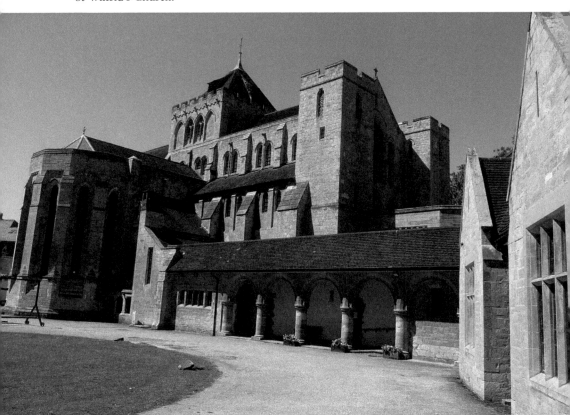

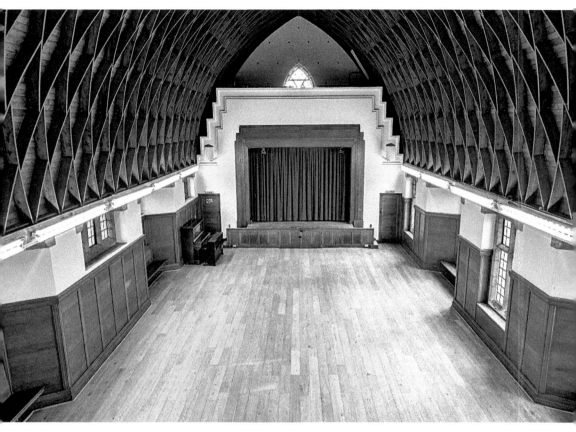

St Wilfrid's Church – the Parish Hall.

date. Moore's plans were approved by Harrogate Borough Council in March 1905 with the foundation stone being laid on 18 April 1906. The first section of the new church (the nave and baptistry) was dedicated on Saturday 4 January 1908 by the bishop of Knaresborough. The exquisite chapels of St Wilfrid and St Raphael were consecrated by the bishop of Ripon on St Barnabus Day 1914, with a temporary altar set up in the western end of the nave. Thereafter work was not resumed until the end of the First World War, the magnificent Parish Hall to the south, built in 1933–34, being especially interesting on account of its extraordinary lamella roof. Also of high importance, the lovely Chapel of Our Lady was dedicated in 1935, which ended the main constructional work.

 The most immediately arresting thing about St Wilfrid's Church is its site positioning. Unlike the neighbouring houses, all of which conform to a building line that resulted in the great majority of structures being either parallel to or at right angles with the road, St Wilfrid's is built at an angle. The surprise of this invites inspection, and the viewer is then faced with a mass of softly glowing Tadcaster stone from which rises a squat tower over the crossing and two miniature towers flanking the eastern gable – features that emphasise rather than detract from the

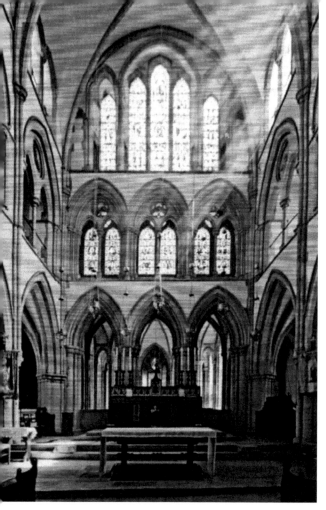

St Wilfrid's magnificent interior.

great height of the vault beneath. The western gable, most unusually, is not built at right angles to the nave walls, but protrudes as a great 'v', which some viewers have likened to the prow of a ship. As a detailed description of the wonderful interior of this Grade I-listed monument is beyond the scope of this book, we must content ourselves with noting that everything within is of the very highest quality. In all but name this is Harrogate's cathedral. Sir John Betjeman lauded this glorious church in his poem 'Perpendicular Revival i' the North'.

38. Library, 1907

Harrogate's public library in Victoria Avenue is contained in a building that, had it been completed, would have been known as the Municipal Palace, although it was intended to provide the town with a town hall, the specification for which had been drawn up by the Corporation's borough engineer, Frank Bagshaw, in January 1902. This called for a council chamber with public viewing balcony of 1,650 square feet, two committee rooms, a deputation and robing room, a

mayor's parlour, retiring rooms and lavatory accommodation, and separate suites of offices for the town clerk, the borough accountant, the rates with separate subdivisions, the borough engineer, the waterworks engineer, the electrical engineer, the sanitary inspector, the weights and measures office, the courtroom, the magistrates' room, a witnesses' room, around six cells, the public library with departments for lending, reference, reading and a librarian's office, a caretakers' room, and various storerooms. The building line allowed for a structure measuring 256 feet facing Victoria Avenue. After a competition, the prize was awarded to Henry Hare for his superbly executed exercise in Edwardian baroque architecture, which called for a single range of enormous windows ranging along the Victoria Avenue frontage, emphasising the building's solidity and length. The main entrance on the shorter Station Parade side was placed beneath a commanding clock tower, which would have provided Station Parade with its most significant architectural feature. After further discussion, and with the casting vote of the new mayor, Councillor Horace Milling, the council pledged themselves to the continuation of the town hall scheme, determined to spend no more than £40,000 on a building worthy of the town.

Thanks to a generous grant from Andrew Carnegie, the first section of the Municipal Palace was opened in 1907 to contain the public library, but thereafter

Henry Hare's noble design for Harrogate's 'Municipal Palace'.

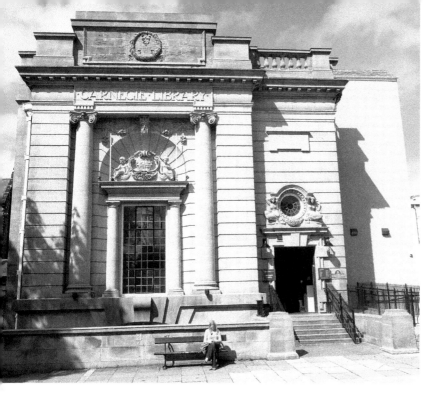

Only the library section of the Municipal Palace was ever built.

the project stalled until the First World War swept away the confidence needed to complete the magnificent building. The rest of the site was used as a public garden, and in 1930 the council converted the former New Victoria Baths into offices for use by the administration. In 2011 the library reopened after a major refurbishment to the building, which enlarged the structure and provided the east façade with windows for the first time. But the building remains as a shadow, an echo, or a whisper of the magnificent but sadly unbuilt Municipal Palace.

39. Marshall & Snelgrove, 1910–11 and 1926

Readers of a certain age will be familiar with the name of Marshall & Snelgrove, the epitome of the luxury departmental store, which thanks to the success of online shopping has almost disappeared from the high street. But Marshall & Snelgrove was never a name to be mentioned in the same breath as Boots, British Home Stores, Littlewoods, Marks & Spencer or Woolworth's. Marshall & Snelgrove was an altogether superior institution that specialised in luxury clothing, toiletries, and household furnishings, with specially employed buyers for such things as hats, gloves, perfumes, fur coats or woollen goods. These buyers would often buy fashions for individual customers, who revelled in the personal attention they received. The firm had been established in 1848 when two successful retailers combined their talents in the Marshall & Snelgrove partnership, opening a department store in 1851 in London's Oxford Street. James Marshall had in fact opened a business in Harrogate back in July 1838 when his business partner was a Mr Wilson, who was

Built in 1911 for Marshall & Snelgrove.

later replaced by a Mr John Stinton. Soon after James' son formed the Marshall & Snelgrove partnership, the business became the nation's top departmental store for luxury sales, opening a branch in Harrogate in 1906 at No. 38 James Street, the rapid success of which caused them to move further east along James Street into a splendid new building at Nos 30 and 32, which opened on 20 February 1911. Designed by James Street architect T. E. Marshall FRIBA, the frontage was faced with handsome white tiles, unique in Harrogate, which manager Robert Button was rumoured to have admired in Blackpool. When the store opened in 1911 it had a lift, a basement strongroom, an electric vacuum system of dust extraction, quarters for residential accommodation and a wrought-iron veranda adorning the James Street frontage. In 1919, the residential quarters were absorbed into the retailing areas, and the business received a first-floor café overlooking James Street, which soon became Harrogate's most exclusive rendezvous. Then, in 1926, the firm extended their store eastwards, after having acquired the property at No. 28, which was demolished and rebuilt in the same style as Nos 30 and 32. A century later, and following the demise of Marshall & Snelgrove after being acquired by Debenhams, the James Street store has been occupied by several businesses, mostly fashion houses. The current occupant is the prestigious Hoopers.

The store was extended eastwards in 1926.

4c. Municipal Buildings, 1871 and 1930

The large stone-fronted building in Crescent Gardens that was opened in 1871 as the New Victoria Baths and which in 1930 was converted into offices for Harrogate Borough Council is, at the time of writing, empty, awaiting new use. In view of this, it would be unwise to be too precise about the building's future, beyond noting that it was acquired by a developer shortly before the council vacated it in November 2017 for conversion into apartments of the very highest quality. The original structure had been built to contain the local authority's prestigious new spa baths, the design of which was obtained somewhat improperly by announcing a competition whose results were then pirated by the local authority's surveyor, James Richardson, who then extracted the best points of each design to produce his own scheme in the Italian Renaissance style – smart or improper? But after

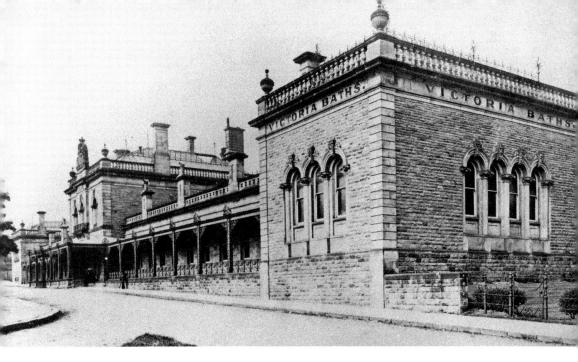

Above: The New Victoria Baths opened in 1871.

Right: Leonard Clarke rebuilt the Victoria Baths in 1931 for the council's offices.

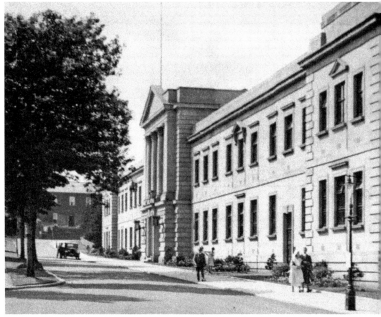

Richard Ellis laid the foundation stone on 4 February 1871, the building was soon finished and ready for opening on 26 August 1871, becoming an instant success with visitors. Between 1871 and 1897, when the larger Royal Baths opened, the New Victoria Baths was Harrogate's largest and best suite of spa baths, connected to large mineral water reservoirs south of the building.

By the late 1920s Harrogate's spa treatments were largely based on the Royal Baths, so the council decided – not without opposition – to convert the New

Victoria Baths into council offices with a large debating chamber and a mayor's parlour where civic guests could be received. This conversion was done by Deputy Borough Surveyor Leonard H. Clarke, who retained only a fraction of the old building, parts of which can still be seen in rear façades. A completely new frontage was provided in the fashionable neoclassical style, the centrepiece of which was an entrance crowned with a gable inscribed with the town's motto, 'Arx Celebris Fontibus' – a city famed for its waters. Opened on 31 October 1931 by Sir Philip Cunliffe-Lister, Harrogate's Municipal Buildings served the town until their closure in 2017, when the authority moved into a new and contentious multimillion pound pile in King's Road.

41. Sun Pavilion, 1933

The long, low buildings of the colonnade and Sun Pavilion that overlook Valley Gardens' northern boundary were conceived as part of a larger scheme to link the Royal Pump Room with the Royal Bath Hospital by means of a new 'tea pavilion', a covered walkway, a new Royal Pump Room at the Valley Gardens' entrance, and an aviary. The scheme was very much a product of 1920s enthusiasm for spa improvement, but delays meant that the first part of the development was inaugurated only on 17 June 1933, when Lord Horder opened the Sun Pavilion

The Sun Pavilion in the 1950s.

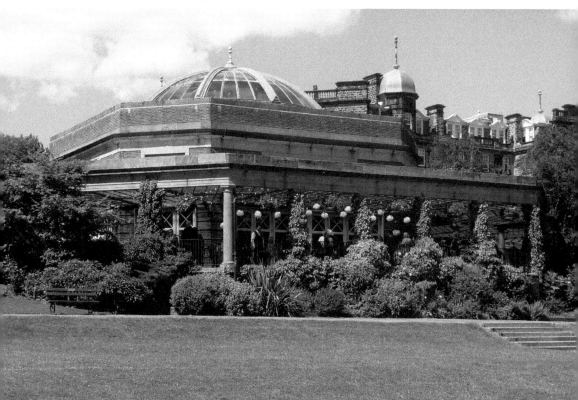

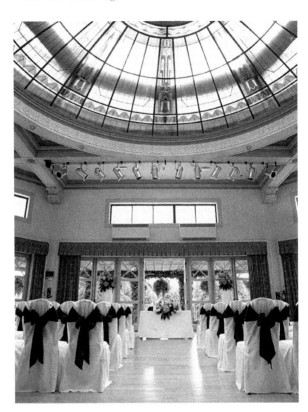

The beautifully restored
art deco interior of the Sun
Pavilion.

and colonnade walk. These had been approved by Borough Surveyor Mr Rivers,
although his deputy, Leonard Clarke, had been their author. The splendidly domed
Sun Pavilion immediately became a popular meeting place, its café presenting an
especially animated view in the summer, and also during the many dances held on the
finely sprung floor. During the 1980s, the Sun Pavilion and colonnade were neglected,
but thanks to the efforts of Mrs Anne Smith (to whom this book is dedicated) and
the Friends of Valley Gardens, both structures were saved and restored, although at
the time of writing, the colonnade still lacks its original glass roof.

42. No. 5 Southway, 1935

Although Harrogate is most usually associated with Victorian and Georgian
architecture, it does have several splendid examples of art deco buildings. These
are primarily private residences that –if not open for public inspection – may
sometimes be viewed from the public footpath. One of the most original art
deco houses in the town is also one of the best preserved, being located at No. 5
Southway and only a few minutes' walk from the Grammar School. Southway was
entirely a product of the 1930s, when eight houses were built, of which No. 5 was
perhaps the most architecturally remarkable. Designed by Marshall and Storey,

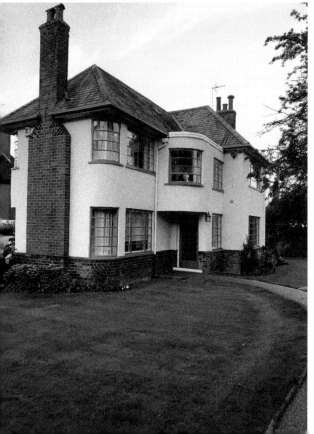

Above: One of Harrogate's finest art deco buildings.

Left: Southway No.5 retains many art deco features.

and built by Collier in 1935 as a family home, it has remained as one to this day. The present owners have devoted great care to restoring the building's beautiful interiors, which include fine floors, curved metal frame windows, sparingly decorated plasterwork, cunningly designed vistas, and that most typical feature of art deco house, a sunroom. Other interesting art deco houses in Harrogate may be seen on Cornwall Road, Leeds Road, and the superb White Lodge on Hookstone Road of *c.* 1935, designed and lived in by Colonel Armistead. All of these buildings can be viewed externally from public pavements. The privacy of their occupants must always be respected.

43. Lounge Hall, 1938–39

When in 1939, in a moment of vandalism and pitiful ignorance, Harrogate Borough Council ordered the demolition of the Spa Rooms, their decision may have been influenced by the thought that the new Lounge Hall was being built next to the Royal Baths as part of a comprehensive programme of spa development. The Spa Rooms had a capacity for around 400, whereas the Lounge Hall would accommodate 700 people, this being more than adequate compensation for the loss of accommodation in the Spa Rooms. The Lounge Hall and the adjoining Fountain Court had been designed by Leonard Clarke, the Borough Surveyor, and the whole ensemble was in a pleasing neoclassical style of architecture. The interior of the Lounge Hall had a beautifully sprung dance floor, and art deco decorations including bird's eye Maple panelling and furniture supplied by Charles Walker and son of Parliament Street. Its perfect acoustic was admired by some of the world's greatest musicians. All this was lost in 2000 including the exquisite Roman-styled Fountain Court, which the council allowed a developer to demolish to accommodate parking for nine cars, the Lounge Hall being occupied by Wetherspoons. This was a repeat of 1939. Had nothing been learned?

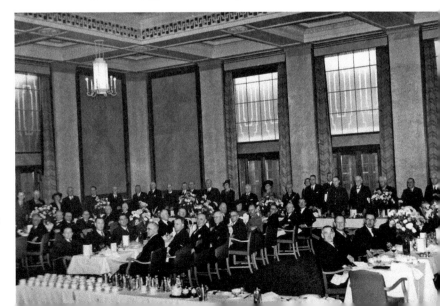

Once a perfect town centre space for public gatherings.

ROGATE, FOUNTAIN COURT, ROYAL BATHS 85962

The Fountain Court when it
was an oasis of calm.

44. Odeon Cinema, 1936

The Odeon was the first cinema to be built in Harrogate after the general
introduction of 'talking' pictures. When Oscar Deutsch created the Odeon
Cinema Group in 1928, the cinema industry was on the point of converting to
sound reproduction, and a new style of architecture was required to accommodate
the revolution and also to express the spirit of the age. This was captured to

The 1936 Odeon was Harry Weedon's masterpiece.

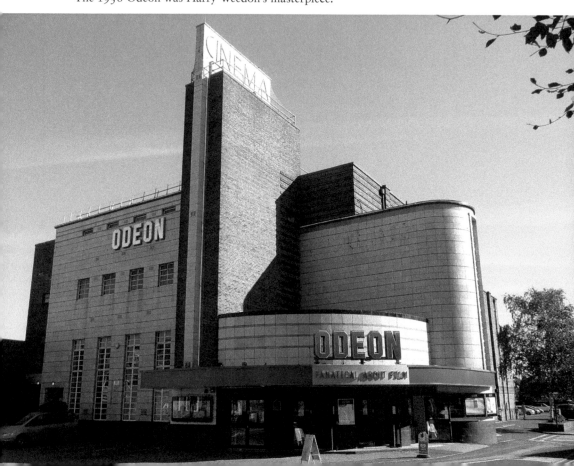

perfection by architect Harry Weedon, who cleverly expressed the Odeon image in his design for the first Odeon cinema at Perry Barr in Birmingham, opened in 1930. When the Harrogate Odeon was planned, company architect Harry Weedon was at his most creative, and he produced a splendidly art deco design, which opened on 28 September 1936 after an expenditure of £31,000. This had an impressive array of internal plasterwork, metallic grills, art deco chandeliers and the latest linoleum floor coverings. Much can still be seen, although the single auditorium was converted into three screens in 1972, with more following. Harry Weedon settled in Harrogate, and twenty-six years after his death in 1970, his Harrogate Odeon featured on the nineteen pence postage stamp. Externally, the Harrogate Odeon remains little altered, although the art deco orange tube lighting of Weedon's original has been replaced with blue lighting.

45. The Exchange, 1965

Currently known as The Exchange but opened in 1965 as Coptall Tower, this monument to 1960s hubris is possibly the most disliked structure in Harrogate. As its nine storeys rose over Station Square in the winter of 1964–65, blocking out light from businesses unfortunate to be in the neighbourhood and creating a wind tunnel for pedestrians, the unreality of architect Harold Taylor's claim that his building would be 'a thing of beauty' was forced down the public's throat. But for his great supporter, council leader Harry Bolland, the new tower was a sign that Harrogate was 'moving with the times' and that it 'showed people in London had faith in Harrogate'. Totally out of scale with its surroundings and built of crude pre-cast panels, the sheer ugliness of the slab resulted in its being given a makeover in 2001, which although possessing a softening effect on the building's

An original drawing of 'Coptall Tower'.

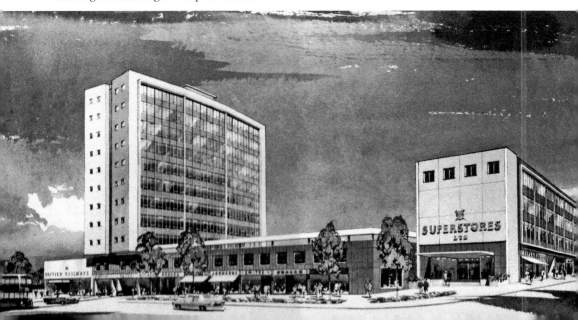

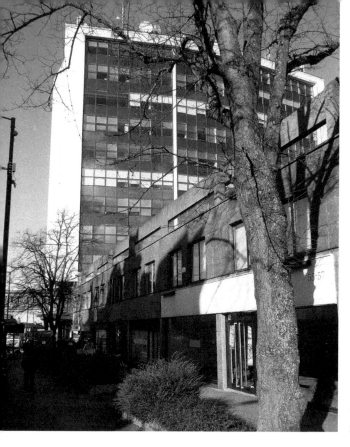

'The Exchange' after its 2001 makeover.

appearance, did nothing to improve the economic wastefulness of the original design for the huge site. Place the tower on its side and this lost opportunity can be seen, for the result would be a two-storey building covering a fraction of the extensive town centre site. Had the developer built a four-storey block over the entirety of the site, the rentable value would have increased many times. Thus were the shareholders' returns squandered to satisfy the hubris of a misguided council leader and a socially irresponsible architect.

46. Conference Centre, 1976–82

There had been calls for Harrogate to have a purpose-built Conference Centre since the 1930s, but it was only after the closure of the spa in 1968 that the move gathered real momentum. In 1971, a report advised that if Harrogate was to develop as a conference and exhibition town, it needed three things: 1. a custom-built Conference Centre; 2. a new hotel adjacent to the Conference Centre; and 3. improved entertainments and nightlife. The result was that in 1973 Harrogate Borough Council received planning consent for the building designed by Harrogate architects Morgan Bentley and partners. This was for a 2,000 seater conference hall built above a plinth containing a department store, a basement car park and various other areas including 20,000 square feet of exhibition space.

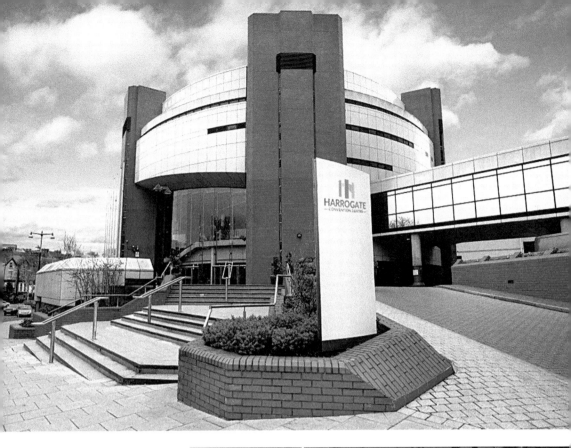

Above: Harrogate
Convention Centre.

Right: The auditorium
can seat up to
2,000 visitors.

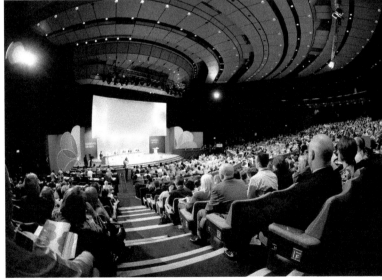

From a spacious entrance lobby, a spiral ramp – Guggenheim-like in design – led
to the upper levels with several entrances to the conference hall and also to suites
of offices for the various technical services connected with the conference business.
When the building opened in 1981, it was lamentably over budget, an economic

The spiral ramp leads to the main.

catastrophe which had begun when an early partner had withdrawn, causing the inexperienced council to shoulder the entire cost – a cost that eventually rose from the total starting figure of £7.8 million to no less than £34 million pounds. This bungling tended to obscure the fact that the new Conference Centre was a much-needed enhancement to the town's principal business of conference and exhibitions. As such, it is at the heart of the local district's economy. The architecture of the Conference Centre is very much of a piece with 1970s brutalism, possibly softened by much use of brick, rather than raw concrete. Although it will probably never be loved, its ingenious design and impressive internal spaces command respect.

47. Victoria Centre, 1991–92

Between 1965, when the Exchange tower was completed over the rubble of the town's beautiful Victorian railway station, and 1992, when the Victoria Shopping Centre opened, Harrogate had undergone a revolution. Before the 1960s the authorities could more or less do with building what they wanted. After the excesses of the 1960s and 1970s, the public backlash came in the form of opposition groups, lobbying, civic societies, and very articulate expressions of public opinion. Consequently, when the council decided to replace their market building of 1938, a steel-framed building clad in artificial stone, they held an architectural competition, which was judged by the public at a series of exhibitions held in the Lounge Hall. The winner was a design by Manchester architects Cullearn and Phillips whose elegant stone façade was based on Palladio, and which naturally became an immediate target for ridicule by the architectural mob who fawned round the ghastly new Labour movement, hating it precisely because it presented everyman with architectural nobility. Some writers went out of their

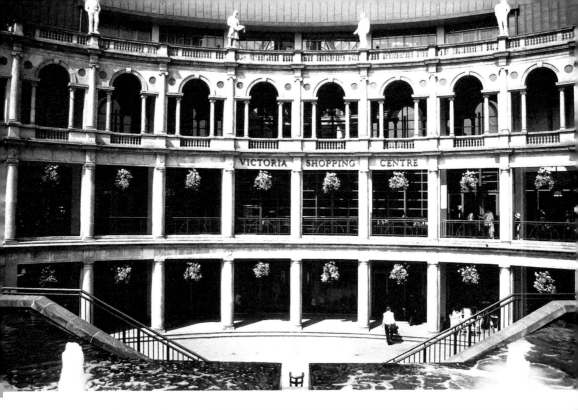

Above: Palladian influence on the Victoria Centre's architecture.

Right: After the alterations of 1999.

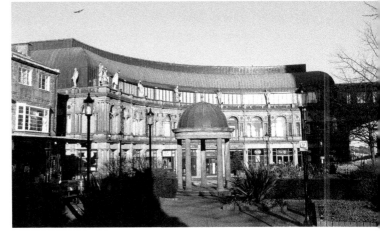

way to mock, ridicule and condemn the public's choice, and anyone who dared to express admiration for the magnificent Jedburgh sandstone, the correct classical proportions of the beautiful columns and arches, the green copper roof, or the spacious display windows was judged and condemned as reactionary. True, the uninspiring statues were an afterthought, replacing the original classical subjects, but they are relatively unimportant. What mattered was that after decades of prefabricated mass-produced ugliness, bereft of anything noble or beautiful that pleased the mind and gladdened the heart, the public had chosen something that tried to express these sentiments. Yet it was ironic that within only seven years of its opening, a new owner introduced changes that reduced the effectiveness

of Cullearn and Phillips original by filling in the sunken piazza to the south, extending the top-floor retailing area at the expense of a delightful terrace café, and glazing in the southern ground-floor arcade.

The Victoria Centre's balustrade is lower in scale than the guttering of the neighbouring Victorian domestic premises of *c.* 1870, the rest of the centre's height being cleverly filled by the curved copper roof. The bulk of the entire building is balanced by the bulks of George Dawson's Cambridge and Prospect crescents at the other end of James and Cambridge streets, both of which – incidentally – are built of fine stone and in the Italian Renaissance style of architecture. All things considered, a fine addition to Harrogate's street scene.

48. Millennial Hall, 2000

When in 1938–39 Harrogate Borough Council tore down the 1835 Spa Rooms to save little over £700 needed to repair the monument's roof, they destroyed the architectural heart of the town and left its most valuable site as an empty wasteland until they built a new exhibition hall on the site in 2000. At the time, voices were heard calling for the restoration to the site of the six magnificent Doric columns from the old Spa Rooms, which after 1939 had been stored and eventually re-erected as a folly at Harlow Carr. In the event, the decision was taken to pay tribute to Harrogate's finest building by fronting the new exhibition hall with replicas of the columns, and designs were prepared by the Parr Partnership. So far so promising. But when the new hall – which with devastating lack of imagination

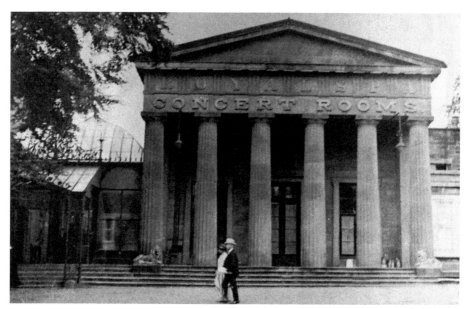

The 1835 Spa Rooms, destroyed in 1939.

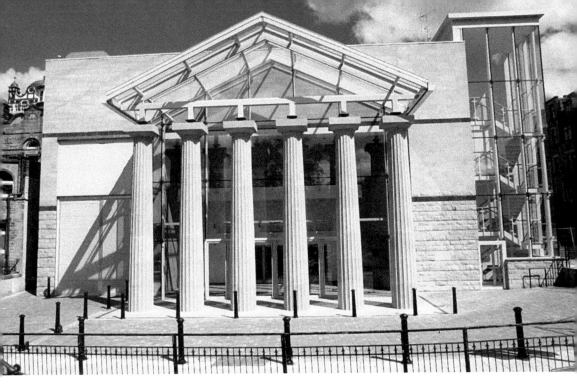

Millennial Hall of 2000 paid tribute to the Spa Rooms.

by the authority was named Hall M – was opened on 5 September 2000, it should have been obvious to all viewers that something was wrong. The six Doric columns carried no entablature, pediment or tympanum, but rather a flimsy-looking triangular assemblage of glass and girders. Far worse however, the symmetry that for over 3,000 years has been at the heart of classical design was wrecked by a pointless glass tower to the immediate south of the entrance, an aberration wholly at odds with classical balance and harmony. The unique opportunity to link directly with the Royal Hall was also lost by creating a useless 4-foot-wide gap between the two buildings. It is to be hoped that when the present exhibition hall is replaced, its successor will include a proper reconstruction of the façade of Harrogate's most perfect building, once more integrated with the Royal Hall.

49. The Inspire, 2003

The Hornbeam Park Pyramid, as it has been called, is a splendid example of the marriage of innovative architecture and progressive engineering design. Officially named 'The Inspire', this strikingly original and really rather beautiful building on the Hornbeam Business Park has provided Harrogate with a splendid example of how visually impressive contemporary business headquarters can be. Conceived by Chris Bentley, Managing Director of Hornbeam Park Developments, as a glass-faced pyramid 40 meters in height containing five stories over 1. 2 acres of footage, the whole containing 1,580 square meters of office, 'The Inspire' is only one of

Left: The splendid Inspire at Hornbeam Business Park.

Below: Hornbeam Park's growing range of contemporary buildings.

several imaginatively designed buildings at Hornbeam, the others being 'The Lens' and 'The Hamlet'. The original inspiration for both The Inspire and The Lens came from Mr Bentley, the architectural planning of the former being done by Adrian Taylor, PH and S Architects, the latter being worked out by Peter Knowles.

Hornbeam Business Park on Harrogate's southern fringes began to develop in 1952 when Imperial Chemical Industries moved in, creating laboratories and research centres, one of whose products was Crimplene, named after the neighbouring River Crimple. Later, Harrogate's College of Art and Technology also moved onto the site and this increased occupancy led, in 1992, to the opening of a Hornbeam Park railway station. Future development here includes provision for smaller 'starter' businesses, which should become a valuable amenity in a town with high land and property values. From the point of architectural and constructional innovation, Hornbeam Park is certainly in the vanguard.

50. Everyman Cinema, 2016

Before the Everyman cinema opened on 9 September 2016, Harrogate's last new cinema opening had been on 18 September 1937 when the Regal (later ABC) had opened. At that time, the town possessed six cinemas: the Central, Gaumont, Odeon, Ritz and St James along with the new Regal. But by 2014, when plans were published for a new cinema in Station Parade to replace Beale's Department Store, only the Odeon was still screening films. Designed by Harrogate-based developers 4Urban Ltd, the new Everyman cinema was part of a stone-faced building on Station Parade that filled the entire site between Albert and Raglan streets, with room for shops and restaurants round the ground-floor frontage. Within a short time of opening, the new Everyman cinema had

The elegant stone frontage of the Everyman cinema.

One of the Everyman's comfortable interiors.

The Everyman's bar and café overlooks Library Gardens.

established high standards for the comfort and cleanliness of its seating, its special facilities for private screenings, and the spaciousness of its catering and bar facilities, one of which offered customers splendid views from its balcony seating area across Library Gardens. The principal façades, punctured by ranges of severely rectangular windows, was a very fashionable concept at the time of construction. Some may regret that the ground-floor colonnade does not extend fully along Station Parade.

Acknowledgements

The author is grateful to the following individuals for the assistance they gave him in the writing of this book:

John and Vivien Abel for permission to photograph Grey Garth from their garden, and for providing the author with information about the building. Rachel Auty and her colleagues at Harrogate Theatre for helping the author during his visit of 6 May 2018 to photograph the auditorium. Jane and Peter Blayney for permission to reproduce the image of the restored Old Magnesia Well in winter, for which they hold the copyright. Dominic Butler for providing the author with a generous range of photographs of the Hotel Majestic, of which images on pages 65 are copyright the Hotel Majestic. Councillor Jim Clark for assisting the author in his attempt to gain admission to Harrogate Theatre for photographic purposes. Revd Matthew S. Evans, Incumbent of Christ Church, for providing the author with information regarding photographic material. Garden City Collection for providing the author with permission to reproduce the photograph of the interior of The Gables shortly after its construction. Note: The Gables is now divided into two residences – Grey Garth and Grey Gables. Tim Hardy for the portrait of the author. Harrogate Borough Council for permission to use their map as a basis for which to redraw the map used in this book to show the location of the fifty buildings described in the text. Harrogate Club for access to their premises. Mark Hinchliffe for providing the author with access to his home, The Chapel HG1, and the photographs reproduced on pages 55 and 56 whose copyright is held by Alex Telfer. Hornbeam Park Developments Ltd for providing the author with the photograph on page 92 for which they hold the copyright. Lynne Hudson of Harrogate Convention Centre for providing the author with photographs of the Sun Pavilion, Exhibition Hall 'M' and the Royal Hall, reproduced on pages 66, 81, 87, 88 and 91 for which Harrogate Convention Centre hold the copyright. Ian Lamond for his photographs of the Harrogate Club's interior. Graeme Lee, Group CEO of Springfield Health Care, for providing the author with information about the future development of Grove House. Joan and James Love for permission to photograph Grey Gables from their garden, and for providing the author with information about the building. The Mercer Art Gallery, Harrogate Borough Council, for providing the Simon Miles photograph of the gallery's interior (copyright Simon Miles). Richard Myers for sending the author a copy of his splendid monograph on Grey Gables. Hak Ng, proprietor of the Royal Baths

Chinese Restaurant, for providing the photographs on pages 57–8, for which he holds copyright. Robert Ogden of Ogden of Harrogate for permission to reproduce the image on page 42 of Ogden's frontage. Rebecca Oliver, Facilities Manager at St Wilfrid's Church Parish Office, for providing the photograph of the exterior of St Wilfrid's (copyright St Wilfrid's, PCC 2017) and photographs of the Parish Hall interior and the nave interior, pages 73–4 (copyright St Wilfrid's, PCC 2017, photographed by Marcus Craven). Lee and Les Parkes for providing the author with information about their home at No. 5 Southway, and for the two photographs reproduced on page 82, for which they hold the copyright. David Ritson, General Manger, for providing the author with permission to reproduce the photographs of the Old Swan Hotel from the hotel's website, including the images of the Wedgwood Restaurant. Trina Gill, of HRH Group Marketing, for providing the author with photographs of the White Hart, for which HRH Group Marketing hold the copyright. Sophie Walter, Collections Officer with the Garden City Collection, for information about the Garden City Collection. Richard Wood, General Manager, Crown Hotel, for providing the author with a generous range of photographs of the Crown Hotel's interior (copyright Bespoke Hotels).

All other images are the author's copyright or have been provided by the Walker-Neesam Archive.